IMAGES
of America

HOUSTON'S
COURTLANDT PLACE

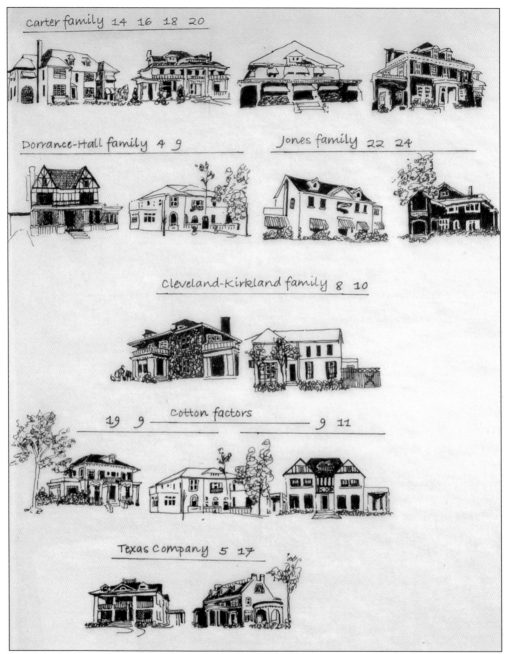

A rendering of Courtlandt Place homes illustrates the interconnections of founding Courtlandt Place families. (Courtesy of Alexandra Schwenke.)

On the Cover: Snow blankets the mansions and lawns of Courtlandt Place in Houston, Texas, around 1925. Pictured from left to right are Winifred Safford, Alice-Baker Jones, Effie Hunt, and dog Pet Brown. A snowfall was an extraordinary and unexpected event on the Texas Gulf Coast. (Courtesy of Woodallen Photography.)

IMAGES
of America

HOUSTON'S
COURTLANDT PLACE

Sallie Gordon and Penny Jones

ARCADIA
PUBLISHING

Published by Arcadia Publishing
Charleston SC, Chicago IL, Portsmouth NH, San Francisco CA

Printed in the United States of America

Library of Congress Control Number: 2009921909

For all general information contact Arcadia Publishing at:
Telephone 843-853-2070
Fax 843-853-0044
E-mail sales@arcadiapublishing.com
For customer service and orders:
Toll-Free 1-888-313-2665

Visit us on the Internet at www.arcadiapublishing.com

This book is dedicated to the legacy of Courtlandt Place
and to its residents, past, present, and future.

CONTENTS

ACKNOWLEDGMENTS

Houston's Courtlandt Place was made possible by the contributions of so many in Houston and across the country. We are deeply beholden to the descendants of the founders of Courtlandt Place for their honest interviews and generosity in sharing their astonishing wealth of family photographs and stories. For contributing photographs from their archives, we thank Nancy Beck, Steven Fenberg of Houston Endowment, Joan Ferry of Palmer Memorial Episcopal Church, the Houston Country Club and David Brollier, Edward Kopinitz, Alan Montgomery of Woodallen Photography–Houston, and Lee Pecht of Woodson Research Center, Fondren Library, Rice University. For their willingness to contribute to the research of this book, we thank Susan Bell and Frances Tremble. For sharing their amazing talents, we thank Benjamin Hill and Alexandra Schwenke. For their excellent proofreading, we are indebted to Susan Bell, Darla Comeaux, Peggy Dorrance Powers, Caroline Schwenke, and Dixie Swanson. For their early encouragement and continued support of this project, we are grateful to historian Betty Trapp Chapman and the residents of Courtlandt Place, in particular Mary and Murray Air, Debbie Crabtree, Mike Heim, Michael O'Connor, Cathryn Selman, Robert Taylor, and, for his unfailing sustenance, chef Ken Schwenke.

INTRODUCTION

In the late 1960s, a reporter from the *Houston Post* asked a Courtlandt Place resident to explain the neighborhood's mystique. "The roots of Houston are in Courtlandt Place," was the reply. "From here, they spread all over town."

Houston was founded on commerce, and Courtlandt Place, established 1906, was intended for those best at it. Its founders were among Houston's first big businessmen: the heads of lumber companies, cotton factorages, law firms, brokerage houses, and mercantile companies. They were the Old Guard with established fortunes and pedigrees and considered themselves socially distinct from the oil wealth beginning to flow into Houston. Their talent, energy, and resources molded the developing city, and their profound influence on business, education, government, civic organizations, cultural foundations, philanthropies, and social clubs continues to shape Houston today.

Overlapping blood and business ties imparted a family compound atmosphere to Courtlandt Place. Two generations of the prodigious Carter clan built four homes on the boulevard. W. T. Carter Jr. married Lillie Neuhaus, niece of Courtlandt Place resident Charles Neuhaus. Next-door neighbors Murray Jones and Irma Hunt were brother and sister. Resident John Dorrance bought a house on the street for his daughter, Virginia Hall, and Lois Kirkland built a home next to her father, Alexander Cleveland.

John Dorrance and Edwin Neville, partners at one time in the cotton business, built adjoining homes, and cotton factor Wanroy Garrow, whose father was Dorrance's first Houston employer, lived on the boulevard. Founding directors of the Texas Company, Judge James Autry and T. J. Donoghue, built homes on Courtlandt Place.

Courtlandt Place names echo down the decades. W. T. Carter established and managed the Carter Lumber Company, one of the largest business concerns in Houston, and was arguably the most renowned and successful lumberman in the South. His son W. T. Carter Jr. eventually oversaw the operations of more than 50 family-owned companies and was a city councilman, a commissioner for the Port of Houston, and a founder of Gibraltar Savings and Loan. The younger Carter brought cable communications to Houston in the 1950s. The Carter family built an airport and brought the first airmail service to Houston. Later purchased by the city and renamed Hobby Airport, it became Houston's first municipal airport.

Frankie Carter Randolph was a National Democratic Party committeewoman and a driving force behind the League of Women Voters. She initiated the city manager concept for Houston and was a founder of the Junior League of Houston. Her husband, R. D. Randolph, was a director of Texas National Bank.

Dr. Judson Taylor, married to Jessie Carter, was Houston's first orthopedic surgeon and a medical pioneer. Taylor helped establish the Dental Branch of the University of Texas, was instrumental in founding a permanent blood bank for the Texas Gulf Coast, was a founder of Jefferson Davis Hospital, Houston's first charity hospital, and was influential in bringing M. D. Anderson Hospital to Houston. He served as president of both the Harris County and Texas medical societies. Judson J. Carroll, married to Lena Carter, was a nationally recognized amateur ornithologist and a major figure in the Open Forum, which invited noted intellectuals to Houston to lecture and debate.

Edwin Neville was one of Houston's most prominent businessmen both in cotton and banking. He served as president of the Houston Cotton Exchange, was director of four major companies as well as Union Bank, was an early financial backer of the fledgling Kinkaid School, and was a

force in the Houston Community Chest. His wife, Daphne Palmer, built Palmer Memorial Chapel, now Palmer Memorial Episcopal Church, for Rice Institute.

President of Houston's largest wholesale grocery business, Alexander Cleveland was president of the Houston Chamber of Commerce, president of the Houston Red Cross, a trustee of Rice University, and a member of the Houston School Board. Virginia Cleveland and fellow resident Monie Parker were founding members of the Museum of Fine Arts. Cleveland's son-in-law William Kirkland was president of Houston's largest bank, First City National Bank.

Wanroy Garrow was president of the Texas and Houston cotton exchanges. The obituary for John Dorrance, a vice president of the Houston Cotton Exchange, praised him as playing "a prominent part in the development of Houston as a major cotton center of the world." Dorrance's son-in-law, Donald Hall, built the Warwick Hotel and other Houston landmark buildings.

T. J. Donoghue, vice president of the Texas Company, later Texaco, was instrumental in the organized development of the oil business in Texas. Judge James Autry was first general counsel of the Texas Company and a pioneer in oil and gas law. His wife, Allie Kinsloe, donated Autry House to Rice Institute as a student center.

Social clubs also felt the stamp of Courtlandt Place founders. In 1904, ten residents helped establish the Houston Golf Club, which in 1908 became the Houston Country Club. In 1938, R. D. Randolph and Charles Neuhaus's son, Hugo, were signatories to the charter for the Bayou Club.

The development of Courtlandt Place marked Houston's burgeoning awareness of a refinement beyond local and Texas tradition. Homes were designed and built for very sophisticated people, most of whom had been educated in the East, summered in places like Lake Placid and Colorado's Broadmoor Hotel, and had taken at least one "Grand Tour" of Europe. The eclectic architecture incorporated the diverse historical precedents of Classical, Mediterranean, Tudor, Georgian, and Colonial Revival styles characteristic of the American Beaux Arts movement. History was not replicated; historical details were used to embellish houses incorporating the most modern domestic technology, floor plans, and ample service space of the period.

The craftsmanship that distinguished these homes a century ago makes them irreplaceable today. The finest architects worked in Courtlandt Place and included Birdsall Parmenas Briscoe, grandson of Andrew Briscoe, a hero of San Jacinto, and great-grandson of John R. Harris, founder of Houston's early rival, Harrisburg. The urbane Briscoe moved easily among the Courtlandt Place set, garnered commissions for six residences, and remodeled a seventh. Alfred Finn, architect of the San Jacinto Monument, was responsible for one residence. John Staub, who stamped his imprimatur on Broadacres and River Oaks, designed one house and made modifications to two others. The Fort Worth–based firm of Sanguinet and Staats designed six homes. Carlos Schoeppl, later famous for Mediterranean Revival houses in Florida, and the New York firm of Warren and Wetmore, architects for Grand Central Station in New York and the Texas Company building in Houston, each designed one house on the boulevard.

Life on Courtlandt Place was defined by socially prominent, well-to-do people living in grand homes amid hordes of rowdy children, horses, ponies, cows, and chickens. The self-contained subdivision brought residents physically closer than had their baronial downtown Houston estates, which typically covered a half to an entire city block. Their lives were productive but slowly paced by today's standards. Parents took time to loll about with their children, and social interaction was a staple of the day.

According to the 1989 application for state historic designation, "The neighborhood was developed so the residents could share the experience of living with each other without the intrusion of outsiders. . . . Many of the homes had large galleries where much of the casual social activity centered. The sidewalks were wide for comfortable strolling . . . and a prescribed openness [was maintained] in front of each house." Cooks, butlers, and maids were important family members and wielded great influence in daily activities. In an interview conducted in the 1980s, the elderly Effie Hunt Heald, who lived nearly all of her life in her parents' home on the boulevard, still remembered the names of the many domestic servants on the street and for whom they worked.

Courtlandt Place families were the beneficiaries of wealth and privilege but were not immune to the travails of ordinary life. Two families lost a husband/father to an early death; three experienced the death of a child; several experienced financial reversal. There were stresses and family conflicts; at a time of limited medical interventions, serious illness, including isolated alcoholism, was part of life in this enclave.

By 1912, there were 12 property owners in Courtlandt Place. The Courtlandt Association was formed with 10 trustees for the purpose of perfecting and perpetuating the standards set forth by the original Courtlandt Place Improvement Company, "to thus create a district restricted to the erection of residences of good class" and assure conditions free from "noise, dust, constant traffic and other annoyances incident to location upon public streets in a populous city." In addition to running the daily business of the neighborhood, trustees exercised oversight of real estate transactions and wielded this power to screen prospective residents. Anyone not "up to snuff" found himself—and his checkbook—shut out. Marie McAshan, in A Houston Legacy, wrote, "They kept restrictions high as to family background, lot size, architecture, and above all, congeniality in philosophy and politics." This de facto control continued through World War II.

Events occurred in 1912 that would prove crucial to the survival of Courtlandt Place. First, the trustees established six restrictive covenants to be carried in all Courtlandt Place deeds. Pivotal was the first: "No business house or houses, sanitarium, hospital, saloon, place of public entertainment, livery stable, resort or dance hall, or other place of business, shall ever be erected on said lot, or any part thereof." Most significantly, the restrictive covenants were not limited by a fixed term and were mandated in perpetuity. The fortuitous ramifications of that mandate, an innovation among Houston neighborhoods at the time, became clear more than 50 years later during the social upheaval and suburban flight of the 1960s and 1970s.

The second event marked the first great challenge to the neighborhood's existence. In its early years, Courtlandt Place was "out on the prairie" with open access through its east and west entrances. By 1912, a new development to the west, Montrose, began to send increasingly heavy traffic down Courtlandt Place Boulevard to downtown, threatening the neighborhood's insular character. Sterling Myer, the developer of Courtlandt Place, commissioned architect William Ward Watkin to erect a brick wall across the western end of the boulevard to cut off the flow. J. W. Link, the developer of Montrose and a power player at Houston city hall, objected. Link wanted a direct downtown route from Montrose and, probably more to the point, from his own sprawling new mansion on Montrose Boulevard. Courtlandt Place was in his way. At Link's urging, the city sued to condemn the wall and open the street.

In a settlement reached on November 27, 1912, Courtlandt Place agreed to remove the wall, which had stood for fewer than six months. In exchange, the city was "to pave and maintain Courtlandt Boulevard and approaches thereto, install street lights at both ends of the Boulevard, and pass and enforce proper traffic ordinances protecting the Boulevard from heavy and objectionable traffic." This clause would be a critical—and essential—tool for preservation in the years to come.

On the eve of World War I, 14 homes were occupied or under construction on Courtlandt Place, and no further building commenced until after the war. Four more homes were constructed by 1937, completing the historic Courtlandt Place recognized today.

Between the wars, Courtlandt Place continued to set the standard of sophistication and remained a focal point for social life in Houston. Despite the increasing popularity of country club entertaining, residents cleaved to the genteel tradition of receiving guests at home. The magazine La Revue described the Courtlandt Place scene in 1920: "Inside the great gates are homes of magnificent architecture and taste, symbolic of the artistic touch of wives of the owners . . . and present the theory that the home is a symbol of the character of its occupants."

The idyll ended with the close of World War II. Residents found themselves fighting their own war for survival as Courtlandt Place and other vintage neighborhoods lost population to the newer, more fashionable suburb of River Oaks and the large pine-covered tracts west of Memorial Park. Courtlandt Place was encircled and besieged by urban blight of the worst sort. Like rows of dominoes, lovely old homes on neighboring streets fell prey to bulldozers for apartment complexes,

were divided into rental units, or were simply abandoned and occupied by increasing numbers of vagrants. Courtlandt Place's sole defense against aggressive "redevelopment" was its unique restrictive covenants, battered but holding. Still, most Houstonians believed it was only a matter of time before Courtlandt Place, too, would be lost.

In 1969, the situation grew dire. An elevated spur of Texas State Highway 59 intruded into Courtlandt Place's east side, obliterating the large park-like crescent entrance with its impressive stone pillars and grove of heirloom cottonwood trees. Sibling neighborhood Westmoreland Place, already on life support, was decimated, a third or more of its homes lost beneath or marooned behind an expanse of concrete and steel. In a 2006 interview, boulevard resident Glenn Smith remembered the general despair. "When I bought my house in 1969, Courtlandt Place was full of little old ladies in neglected houses waiting to die. My friends referred to my house as 'Glenn's Folly.'"

The 1970s and 1980s brought a glimmer of hope. Baby boomers, escaping the sterility of suburbia, fueled a surge of interest in older houses and historic preservation, and Courtlandt Place residents began to consider solid alternatives for the preservation of their now historic neighborhood. But an unprecedented and extremely bold move was required: repurchasing Courtlandt Place Boulevard from the city and resurrecting the west wall to choke off the corrosive spillover from unsavory commercialism.

The 1912 settlement between Courtlandt Place and the city "to enforce proper traffic ordinances protecting Courtlandt Place Boulevard from heavy and *objectionable* traffic" was the key to obtaining the city's agreement—yet it was almost overlooked. Never officially recorded, the settlement was discovered purely by chance in the 1970s when Courtlandt Place resident Pierre ("Pete") Schlumberger rescued it from a box labeled "Old Papers" in the Houston city secretary's office.

The city agreed to the repurchase but, fearful of establishing a dangerous precedent for street privatization, stipulated that Courtlandt Place must acquire a National Register of Historic Places designation as a condition to the sale. Pete Schlumberger spent the better part of 1976 assembling the documentation needed to apply for the National Register. Scion of an international oil-industry clan and an attorney by training, Schlumberger devoted his time, skill, and resources to the project and assumed a leadership role in the neighborhood. He interviewed original owners and their families, and his attorney's skill was of inestimable value in deed and land research.

Sadly, the application process became mired in undeserved controversy. Some residents believed erroneously that enrollment in the National Register of Historic Places would curtail their property rights or leave them vulnerable to forced entry from busloads of tourists. Despite valiant attempts to inject reason into the debate, emotions were so extreme that the project was abandoned for four years while residents warred over the issue.

Resolution was reached in 1979, and Courtlandt Place was listed in the National Register of Historic Places. Three years later, the neighborhood repurchased the boulevard from the city and rebuilt the western wall. In 1988, residents erected an east wall and gates to better control automobile and foot traffic and mitigate the intrusion of the spur. Children once again romped freely, neighbors socialized on the boulevard, and Courtlandt Place enjoyed recognition as one of Houston's most historic landmarks. A stronger civic association added perpetual membership and mandatory payment of association dues to the bylaws, necessary augmentations for neighborhood stability and enhancement of common areas.

Courtlandt Place today has regained its ancestral rhythms. None of its original 18 homes have been demolished, laudable in any historic neighborhood but positively remarkable in Houston, a city whose zeal for redevelopment is boundless. Demographics have changed, and residents are no longer extended families or business associates, but those who live there respond to the design of their neighborhood in ways the architects and planners intended more than 100 years ago. A difference may be that these neighbors are conscious of the responsibility they hold as caretakers of one of Houston's greatest architectural treasures.

One

DEBUT

In 1906, Houston was poised to become a great city. Rambunctious, unrestricted growth reigned as streetcar lines and the emergence of the automobile pushed the boundaries of the city outward. Commercialism expanded south from its traditional center at Main Street and Texas Avenue and encroached upon the elegant mansions of the city's elite. Their response was flight and the formation of private residential enclaves to buffer the chaos. These new neighborhoods emulated the subdivisions made popular in St. Louis in the last quarter of the 19th century known as the Private Places. Westmoreland Place, platted 1902, was Houston's first Private Place neighborhood, and Courtlandt Place joined it four years later as a smaller, more compact, and ultimately more robust sibling.

In September 1906, Sterling Myer, A. L. Hamilton, and T. A. Cargill formed the Courtlandt Improvement Company and purchased roughly 15 acres of farmland for their new subdivision, Courtlandt Place. Civil engineer A. J. Wise platted the property into 26 lots flanking a wide boulevard with an impressive east entrance marked by stone pillars. The new development straddled the sea change from horse-drawn carriages and gasoliers to automobiles and electric lighting. Homes were equipped with hitching posts, mounting blocks, and carriage steps; household records of several homes show that the gas company, not the electric company, turned on the lights.

Alone on the prairie, Courtlandt Place's open entrances, flanked by low iron fences, were all that were required for this Private Place until 1912, when traffic from J. W. Link's new Montrose addition began to erode the neighborhood's solitude. Concerned by this incursion, Courtlandt Place closed the western entrance with a tall brick wall designed by architect William Ward Watkin, an architect of the campus plan and initial buildings for Rice Institute. Nurseryman Edward Teas provided elaborate landscaping. Despite the project's expense—more than $2,000, a considerable sum in 1912 dollars—the wall was removed in fewer than six months as part of the settlement ceding the boulevard to the city. Although powerful and well connected, Courtlandt Place residents were unable to defeat both Link and city hall.

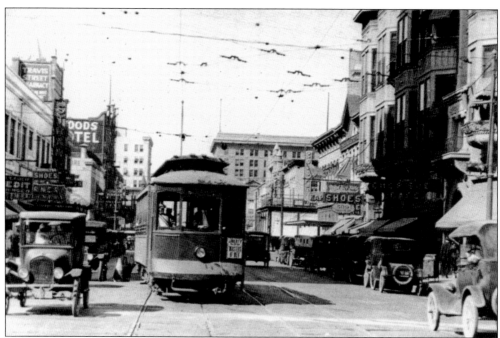

Transportation modes were changing rapidly when Courtlandt Place was founded. The extension of Houston's streetcar lines past the traditional city boundaries and the emergence of the automobile made the recent concept of suburbs "on the prairie," like Courtlandt Place, possible and accessible to downtown. Main Street in the early 20th century was the address for the large mansions of Houston's elite. Many Courtlandt Place families moved to the boulevard from these baronial mansions, some of which comprised an entire city block. Courtlandt Place homes, while quite spacious, constituted "downsizing" for these residents. Almost all of the Main Street mansions were razed to make room for commercial buildings. (Both courtesy of Michael O'Connor.)

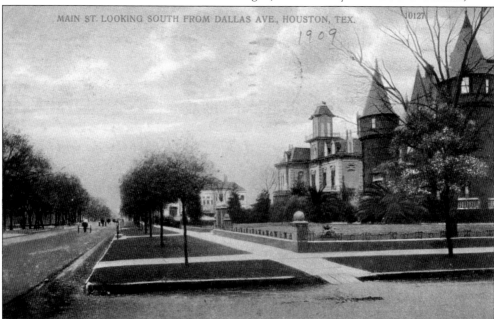

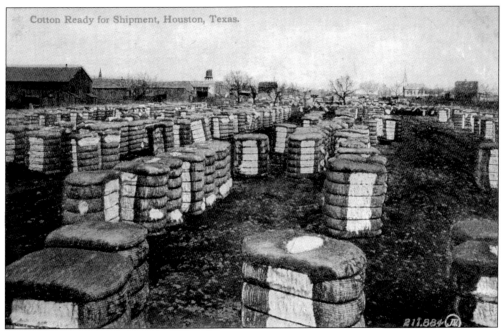

Cotton Ready for Shipment, Houston, Texas.

Prior to oil, cotton and timber were the lifeblood of Houston's commerce. The city was an important railroad hub and port, especially with the dredging of the Houston Ship Channel and turning basin, and was a major center for the international cotton trade. Several Courtlandt Place residents were leading cotton factors and therefore by necessity world travelers. Spindletop roared into life in 1901 and brought oil to southeast Texas, changing Houston forever. At first, timber and cotton families did not welcome the new oil money into their social set. Oil supplanted cotton and timber as Houston's core industry by 1930, by which time the old and new money sets were beginning to mingle. (Both courtesy of Michael O'Connor.)

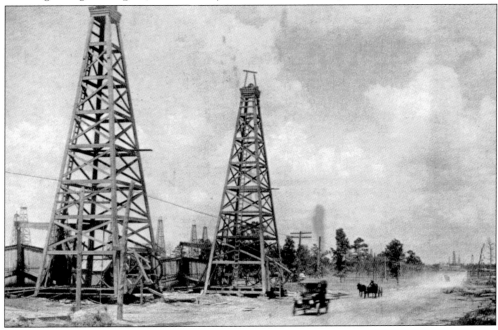

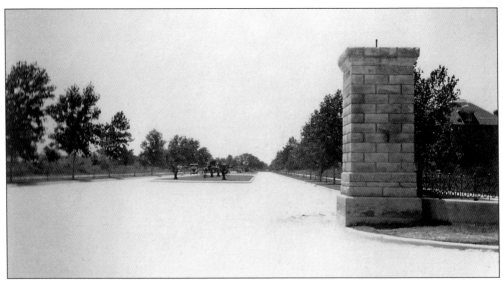

Above, an early view of the east entrance to Courtlandt Place displays its low, decorative iron fence. The "Key to the City of Houston" (1908) noted, "This suburb is located in a pleasant part of the City, beautifully drained, and all the space within the enclosure is paved completely." In a later view of the east entrance prior to 1920, the crescent-shaped approach and flanking pylons with entry lanterns mark the principal entry to Courtlandt Place. Such grand gateways were typical of Private Place neighborhoods and emulated the older, self-contained subdivisions of St. Louis, Missouri. (Above courtesy of the Neuhaus family; below courtesy of Woodallen Photography–Houston.)

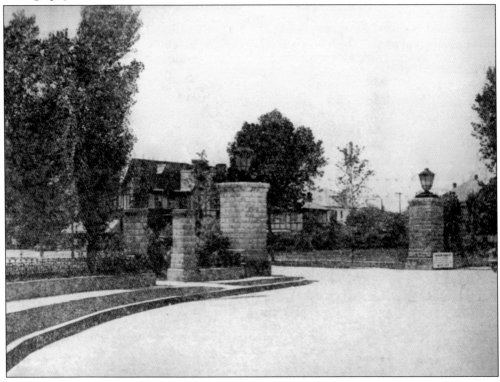

Before World War I, home building technology was arbitrary and relied on architects' and contractors' experience and judgment. Most designs were based on vernacular structures, local practice, and rule of thumb. Building codes would be imposed in the future. With one exception, Courtlandt Place houses were built from original designs by outstanding architects rather than standardized catalogue plans. Charles Neuhaus, who built 6 Courtlandt Place, is pictured at far right in the photograph above. The employment of balloon framing (below), the use of long, single studs, was a common construction technique of the period because of the ready availability and low cost of lumber. The technique was abandoned later in the century when the long studs became more expensive and less available. Balloon-framed structures required fire-blocking at the story levels. (Both courtesy of the Neuhaus family.)

The first Courtlandt Place houses were constructed in much the same way homes had been built throughout the southern United States for the previous 150 years. Crews harnessed mules and worked without electrically powered tools. Tools of the period were mechanically similar to those of the modern day but powered by muscle. Large basements were a necessity to accommodate coal-burning furnaces. Houston home builder Russell Brown, whose slogan was "Homes not Houses," built several Courtlandt Place homes. Brown advertised that his furnaces would "heat . . . the entire house . . . to a uniform temperature of 70 degrees . . . when outside temperature is 0." Some descendants of early Courtlandt Place residents dispute that claim. (Both courtesy of the Neuhaus family.)

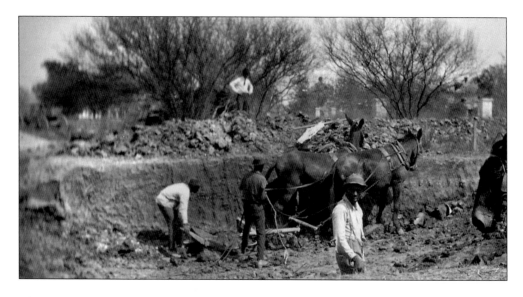

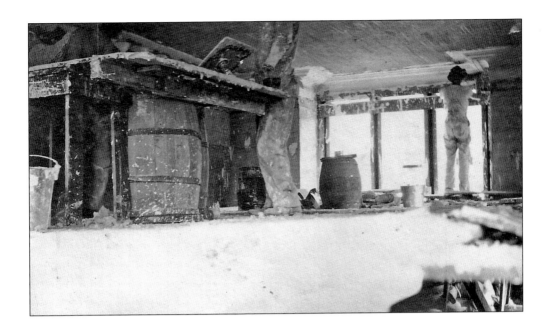

The houses built in Courtlandt Place prior to World War I exhibit the historical eclecticism of the Beaux Arts style. Craftsmanship and detail were paramount in the construction of these houses. Above, a skilled plasterer applies his art. All Courtlandt Place houses have plastered interior walls; sheetrock was a material of the future. Wide front porches were an integral component of Courtlandt Place homes. In the era before air-conditioning, porches, rather than stuffy interiors, served as gathering places for social interaction in the often oppressively warm and humid Houston climate. Below, workmen install a balustrade for the front porch of 6 Courtlandt Place. (Both courtesy of the Neuhaus family.)

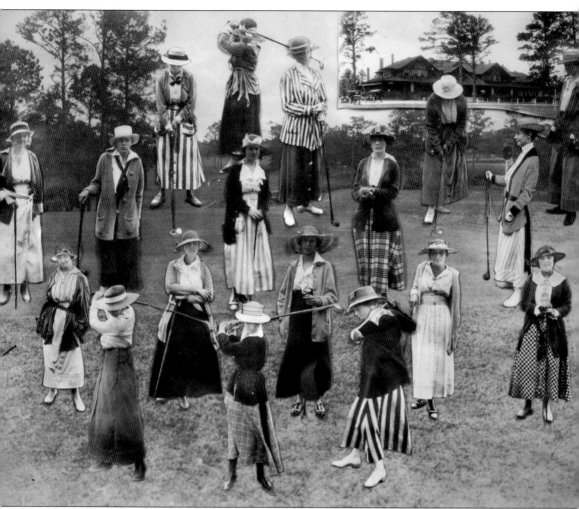

Wealthy Houstonians were exposed to golf in their travels around Great Britain and the European continent and brought the game back to Houston. The first Houston golfers played on rough prairie very near where Courtlandt Place would be developed in 1906. Fairways and greens were carved from undergrowth, and golfers may have used tin cans for holes. This loose association became the Houston Golf Club in 1904 and included 10 families who would later move to Courtlandt Place. The club's first proper course and clubhouse, located on Old San Felipe Road south of Buffalo Bayou below Glenwood Cemetery, were built on property leased from William Marsh Rice. In 1908, club members chartered the Houston Country Club and purchased acreage southeast of downtown on Wayside Drive for a new, larger facility designed by John Staub. The club's division of the Women's Texas Golf Association in 1916 included Courtlandt Place residents Frankie Carter Randolph, Erna Neuhaus King, and Peg Dorrance Wilfong. (Photograph by Benjamin Hill, courtesy of the Houston Country Club.)

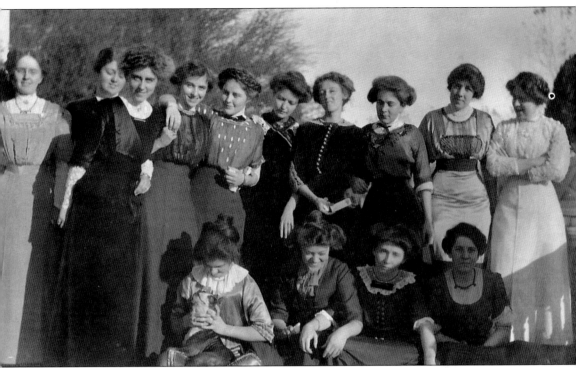

The women of Courtlandt Place gathered frequently in the afternoons, planning events, sewing, or just socializing. They were women of leisure with very few household duties but were social, civic, and philanthropic powerhouses who founded some of Houston's greatest charitable and political institutions. Courtlandt Place women cofounded the Museum of Fine Arts, the Houston Symphony, the League of Women Voters, and the Junior League of Houston. Travel occupied a large segment of these women's lives. The families regularly journeyed to Europe for extended periods and always left hot, humid Houston for the duration of the summer. Some families traveled on the train with their motorcars, engaging a local chauffeur at various destinations. (Courtesy of Sara H. Stadeager-Andersen.)

Young, well-dressed Courtlandt Place children toddle down the boulevard pulling their toys. Early residents embraced a rather formal, Edwardian lifestyle, which remained intact until after World War II. Descendants of original residents remember their grandparents' adherence to a formal regimen for meals, including formal dinner dress and service. Adults who grew up on Courtlandt Place recall that, as children, they enjoyed virtually unobstructed access to all the homes on the street. The children established close relationships with the neighborhood cooks and memorized their cookie-baking schedules. At least two Courtlandt Place homes originated their own cookbooks. (Both courtesy of the Neuhaus family.)

Houston was a Southern city and had Jim Crow laws mandating segregation of the races. Despite profound racial and class distinctions, servants were an integral, important, and much revered part of family life, and the large households of Courtlandt Place could not have functioned without them. When Tap (Lucy Waller), the beloved retainer of the Autry family, died, the Autreys held her funeral in their parlor. Some houses employed a staff of six, often including a butler who also served as chauffeur. Servants traveled with the families in the summers to cooler climes, usually leaving a trusted staff member behind to watch the house. A few homes had basement safes where family silver and valuables were deposited when the family was not in residence. (Both courtesy of Woodallen Photography–Houston.)

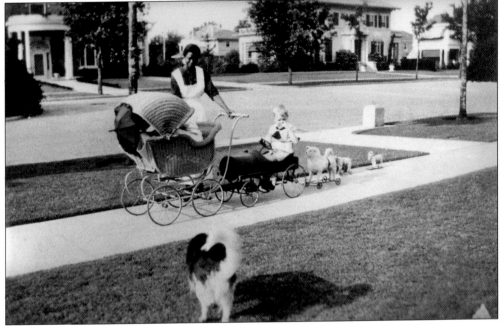

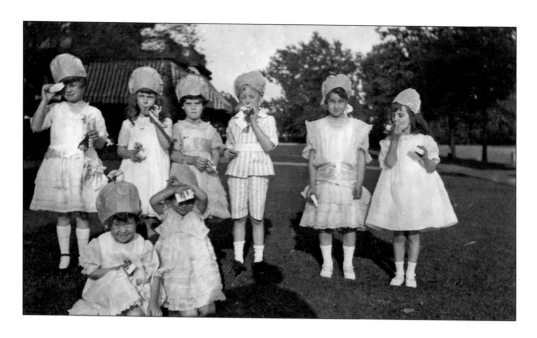

A birthday party was a much anticipated and elaborately choreographed event in the years prior to radio and television. Dances were popular, even for young children. J. W. Garrow of No. 19 mentions a dance for his daughter Estelle in 1914: "dear little Estelles [sic] celebration of her fifth birthday with a dancing party . . . for about half a hundred of her dear little friends—a sight such as none of us may ever again behold." Less formal children's gatherings occurred most afternoons with games played under the watchful eye of family servants. Quilts were spread on front lawns for tea parties and as a resting place for the younger children. Bonds forged among Courtlandt Place children were strong and continued through the families for generations. (Above courtesy of the Neuhaus family; below courtesy of Woodallen Photography–Houston.)

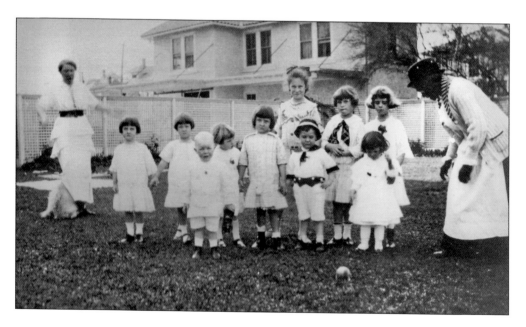

Two

CARTER COMPOUND

Mid-19th-century East Texas was the rough South, more frontier than genteel country. W. T. Carter, founder of the powerful clan so instrumental in the formation of modern Houston, was the son of a Georgia lumberman who moved west to carve his fortune from the region's thick stands of virgin pine and hardwood. Born in Tyler, Texas, in 1856, Carter rose from hardscrabble beginnings to achieve great wealth, first from a succession of sawmills, most notably at Camden in Polk County, and later in Houston banking and real estate.

The road to success was difficult. Carter and his wife, Maude Holley, endured devastating mill fires and started over twice. But Carter had "grit"; one biographer wrote that he "set the standard for a successful lumber operation." By 1908, with business flourishing, Carter moved his family to Houston and a grand Main Street mansion where he and Maude were prominent in the city's social life. Carter transferred his company headquarters to Houston but remained "hands-on" in administration of the mill and other family property at Camden.

Carter completed his house on Courtlandt Place in 1920, joining children Lena Carter Carroll, Jessie Carter Taylor, and W. T. Carter Jr. and their families. Daughter Frankie Carter Randolph and her family lived with the senior Carters. W. T. Carter died in 1921.

W. T. and Maude Carter were tough, industrious, and adaptive with a strong sense of social responsibility, traits they instilled in their children. Their children were rather nonconformist individuals with distinct personalities, divergent lifestyles, and passionate interests who nevertheless remained close-knit. The family moved freely among one another's Courtlandt Place homes and frequently spent weekends and holidays together at the family retreat in Camden. Notwithstanding a formal and socially proper daily existence, Carter daughters Frankie Randolph and Jessie Taylor were famous for their diablerie and sense of fun, and they delighted in perpetrating elaborate practical jokes.

The extended Carter family continues to wield considerable influence in Houston today. None has lived on the boulevard since the 1980s, but the Carter name is linked forever with Courtlandt Place.

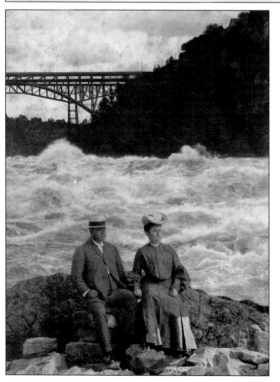

No. 14 Courtlandt Place was completed in 1920 for W. T. and Maude Carter. It was designed by architect Birdsall P. Briscoe, who designed or modified seven Courtlandt Place houses, four belonging to Carters. Georgian and Italian Revival styles mingle in the elegant facade. The interior is distinguished by delicate French-style paneling in the dining room and an impressive oak staircase with Greek key motif. At left, W. T. and Maude Carter strike a pose, seemingly at Niagara Falls. In fact, the photograph is staged in front of a backdrop, a practice much in vogue for studio photography at the time. To the knowledge of present-day family members, the senior Carters, while seasoned travelers, never visited Niagara Falls. (Above courtesy of Michael O'Connor; below photograph by Benjamin Hill, courtesy of Susan A. Whiteford.)

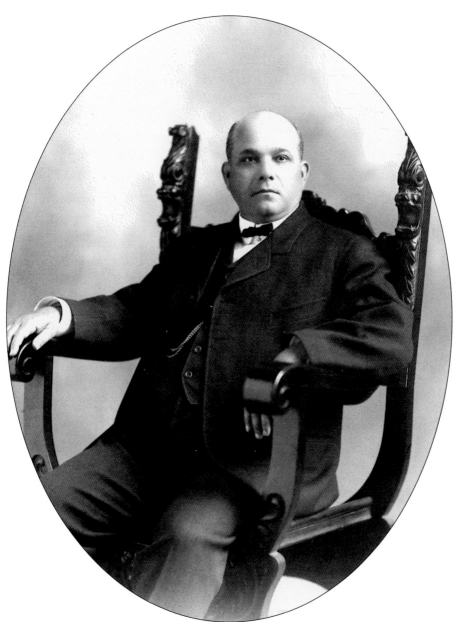

W. T. Carter, "Will," (1856–1921) founded the Carter family fortune. His father, Joseph Carter, built a sawmill in Wood County before 1860. After the Civil War, Joseph's eldest son, John, traveled to Georgia to retrieve a $6,000 inheritance and carry it back to Texas. Joseph then invested in another sawmill in Trinity but lost it to foreclosure in 1876. The mill was purchased and then resold to 20-year-old Will, a younger son, for $26 and a promissory note. Will was an ambitious, brilliant businessman with marked mechanical ability. He was often found with his sleeves rolled up, working in the mill with his sawyers. At the end of his life, Will owned extensive lumber, railroad, and real estate interests. He was a director of the Union National Bank and the Bankers Trust Company and a member of the Houston Chamber of Commerce and the Cotton Exchange. His social memberships included the Houston Club, Houston Country Club, Elks, and Thalian Club. (Courtesy of Sally Binz DeWalch.)

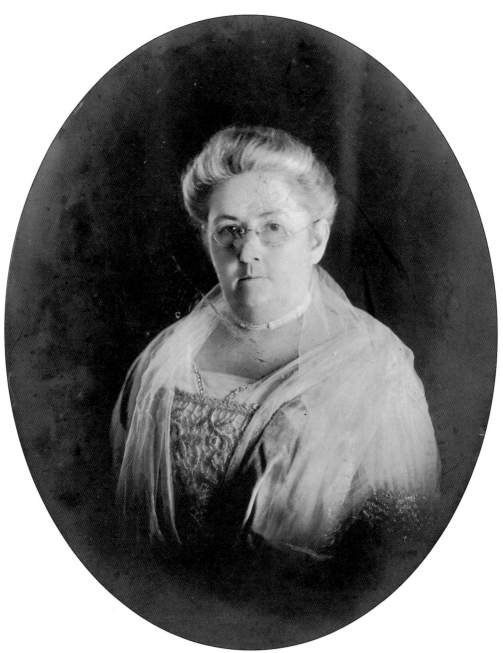

Maude Holley Carter (1858–1929) married Will Carter in 1879. She and her beloved "Willie" had six children: Lena, Jessie, W. T. Jr., Agnese, Aubrey, and Frankie. Maude shared Will's grit and determination and accompanied him through a succession of rough East Texas mill towns as he built his lumber empire. In 1900, Will established a home at Camden, which remained the family's gathering place after he and Maude moved to Houston. Maude's spinster sister Becky lived with the Carters throughout their married life and, as their business and social concerns multiplied, helped Maude run her increasingly complex household. Maude presented a reserved demeanor to the world but, in private circumstances, loved to gamble and have fun. Subsequent generations of Carters adored her. (Courtesy of Sally Binz DeWalch.)

View of Steel Structure W T Carter Bro Davison Jan 7" 1911.
Put up first row of posts Dec 24" 1910

Camden, Texas, was an encapsulated mill town totally beholden to the Carter family. The establishment of the Camden mill departed from the lumbering tradition of following the trees. Camden's railhead and the proliferation of railroads crisscrossing East Texas made it possible for Will to purchase large stands of timber, as many as 180,000 acres in later years, with confidence that his logs would move to market quickly. His Moscow, Camden, and San Augustine Railroad was chartered to link its three namesake towns, a distance of 50 miles. However, after completion of the 7-mile stretch from Moscow to Camden, which provided direct access to market for Carter lumber, the standard-gauge line was never extended. One of the line's locomotives served previously in the construction of the Panama Canal. (Above courtesy of Mary Carter Marold; below courtesy of Michael O'Connor.)

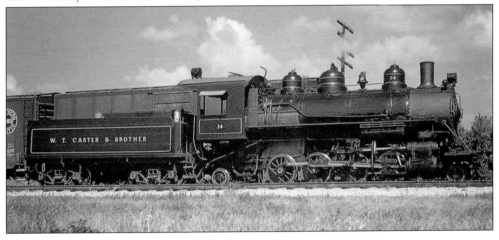

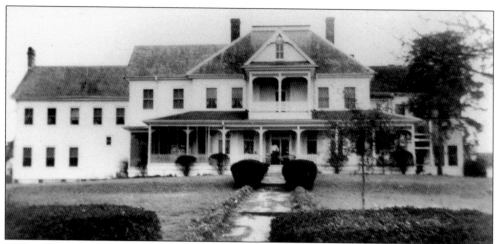

Will and Maude, their children, and later their children's families flocked to the house at Camden for relaxation and fellowship. This 40-room house burned in the 1950s, and perennial Carter architect Birdsall Briscoe was commissioned to design a replacement. His plans were judged to be grandiose, and only the first story was built. Over 100 years later, present-day descendants still return to Camden. Will adored children and reveled in their company. He is shown with some of his grandchildren, a neglected newspaper in his hand and golf clubs forgotten in the background. The sprawling house allowed the Carter grandchildren to interact with adults more closely and perhaps more evenly than was possible on Courtlandt Place, to the delight of everyone. Family members remember Camden visits as magical. (Above courtesy of Betsey Martin; below courtesy of Sally Binz DeWalch.)

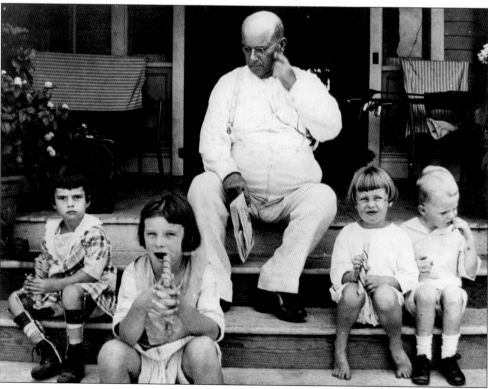

Wednesday Feb 23

The worst has come and writing this on Feb 29 I have had to give up the one who was dearest of all to me God only knows how to console but surely is promises are true and he will temper the bleak winds to me

Will suffered from diabetes and increasing ill health. The later 1920 and early 1921 entries in Maude's journal record "Willie's" last days, and despite hopeful references to "Willie much better today," most reveal a man gravely ill. Her sad entry for Wednesday, February 23, 1921, written on February 29, records: "The worst has come. . . . I have had to give up the one who was dearest of all to me." After her husband's death, Maude never returned to the house at Camden so closely identified with her husband. She purchased a home in Lake George, New York, where she and her sister Becky spent summers enjoying extended visits by Maude's children and their families. Daughter Frankie Randolph especially enjoyed "following the horses" with her mother and Aunt Becky at nearby Saratoga. (Photograph by Benjamin Hill, courtesy of Woodson Research Center.)

Carter daughter Frankie Carter Randolph (1894–1972), her husband, R. D. Randolph, and their children resided at 14 Courtlandt Place with the senior Carters and stayed on after Will's death. Frankie was the chief iconoclast in a family of unconventional thinkers. A competitive golfer, equestrienne, fun seeker, and famous practical joker who was adored by the younger generation, she is pictured at Camden in amusing *dishabille*. Tales of Frankie's derring-do abound, including one escapade relating a teenage Frankie's gallop on horseback through Hermann Park wearing a shoulder holster and pistol. Frankie shared her siblings' commitment to public service; she was a cofounder of the Junior League of Houston and the League of Women Voters. An early supporter of racial integration, Frankie was the first white person in Houston to join the NAACP. In the 1950s, this member of a conservative Republican family worked to elect the Democratic Party's presidential candidate Adlai Stevenson, helped to organize a rump movement challenging the Texas Democratic Party, and became a National Democratic committeewoman. (Courtesy of Sally Binz DeWalch.)

While at the Baldwin School in Bryn Mawr, Pennsylvania, Frankie often visited her brother Aubrey at the University of Virginia. During a social event, Aubrey introduced her to fellow student Robert Decan Randolph, "Deke," (1891–1989), a member of the First Families of Virginia. Frankie had other suitors, including Will Hogg, but Deke prevailed, and they married in 1918. Deke volunteered for service in World War I, joining the Naval Air Corps. He helped design the official "Navy Wings" and served in France. In Houston, Deke entered the brokerage business and later worked for the Carter Lumber Company. Elected to the board of Union National Bank in 1924, he eventually entered the banking business full-time, first at Union Bank and then as senior vice president of Texas National Bank, where he remained a highly esteemed consulting vice president for the rest of his remarkably long life. Deke was a cofounder of the Bayou Club and a lifelong sports enthusiast and athlete. His own mother had been highly unconventional, and he never objected to Frankie's political activities. (Courtesy of Sally Binz DeWalch.)

Frankie Randolph (seated) is flanked on her right by husband, Deke Randolph, and on her left by brother-in-law Judson Taylor. She is wearing a shoulder sash, and the men appear to be paying court. Her great-niece Sally Binz DeWalch believes it was a birthday party in her honor, but as Frankie was a great jokester, no one is really sure. In the second photograph, probably of the same occasion, Frankie, obviously the star, is characteristically talking on the phone. The extended Carter clan gathers around her: brother W. T. Carter Jr. is in the second row, second from left; Deke is seated next to Frankie; sister Jessie Carter Taylor is next to Deke. Frankie was a bon vivant at ease in any social setting, but she abhorred formality and pretension. (Both courtesy of Sally Binz DeWalch.)

Aubrey Randolph, pictured here, was born in 1919 and her sister Jean in 1922. Frankie was a pied piper for her own and all the Carter children, always organizing fun in Houston and Camden. Sally Binz DeWalch recalls an evening in Camden with talk about "bad" children's feet turning black as they slept. That night, Frankie painted all the children's feet black, and there was much consternation the next morning. The Randolphs were accomplished equestrians, particularly Deke, who played polo at the Houston Riding and Polo Club on Westheimer Road. They engaged John Staub to build a stable for their horses on South Post Oak Lane and kept horses at Camden. Daughter Aubrey shared their enthusiasm and is pictured astride her hunter. (Above courtesy of Sally Binz DeWalch; below courtesy of Bonner Sewell Ball.)

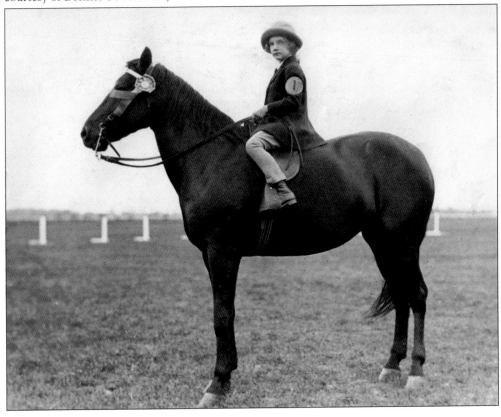

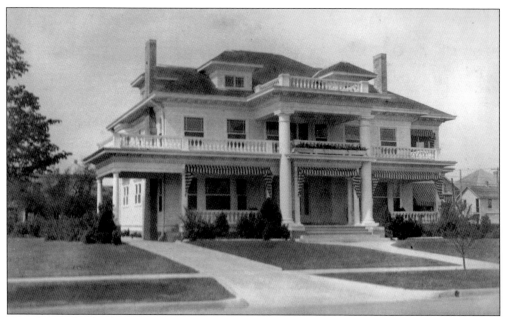

No. 16 Courtlandt Place was completed in 1912 for Lena Carter and Judson J. Carroll and was the first Carter family home on the boulevard. Judson Carroll reportedly was his own house designer and built the Colonial Revival home from a standardized plan, the only Courtlandt Place house to be so designed. Birdsall Briscoe made significant improvements in 1924, which included the addition of superb fireplace mantels carved by Peter Mansbendel. The foyer, central hall, and breakfast room are distinguished by vintage hand-painted Zuber wallpaper depicting birds, a passionate interest of Judson Carroll. The Carrolls hosted many business, cultural, and social functions in their home, but much of their life on Courtlandt Place revolved around children. The Carroll daughters, their cousins, and neighbors had their own soirees, often tea parties on quilts spread on the lawn. (Both courtesy of Woodallen Photography–Houston.)

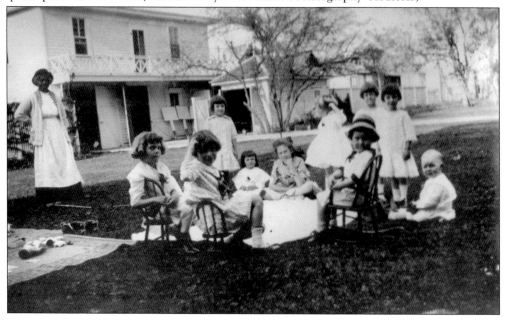

As a child, Lena Carter Carroll (1879–1971) traveled with her family to Camden on a flat car with hot bricks at her feet and a pistol in her lap. Gracious and dignified, Lena was an accomplished hostess who ran her household with a strong hand yet was very child-oriented. She was a powerful example of kindness and generosity for the next two generations of Carters. James Judson Carroll (1877–1938) was orphaned at the age of four and overcame a haphazard upbringing and uneven education. He was an executive with the Carter Lumber Company but had tepid interest in business. Judson's true passion was ornithology, and he was a noted intellectual and leader in the Open Forum, which invited prominent intellectuals to Houston to discuss contemporary ideas. (Both courtesy of Susan A. Whiteford.)

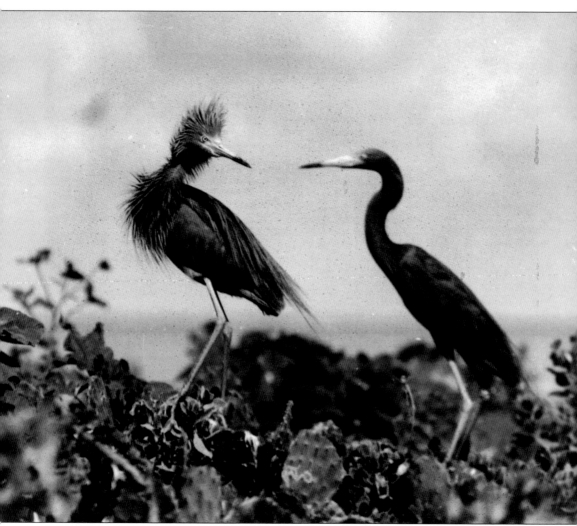

Judson Carroll was a gifted amateur ornithologist and expert on the waterfowl of the Texas Gulf Coast. He received international recognition and prestigious awards for his avian photography. Despite suffering vestiges of a stroke, Judson kept his yacht near Aransas Pass and took every opportunity to explore the marshes and coastline with his big Graflax camera at the ready. He is credited with saving one of Texas's most spectacular bird species, the roseate spoonbill, from extinction, and he compiled one of the most extensive collections of bird eggs in Texas. Carroll Island in the Laguna Madre between the Aransas National Wildlife Refuge and Matagorda Island holds a monument commemorating his efforts to protect the nesting areas of Texas waterfowl. He invited the Audubon Society to use his spacious Courtlandt Place home as its regional headquarters. (Courtesy of Susan A. Whiteford.)

Carroll daughter Lena and her cousin, Billy Carter, son of W. T. Carter Jr., are dressed as a Red Cross nurse and ambulance driver, reflective of the nation's focus on the war in Europe. The senior Lena had particular interest in nursing and headed a nurses' aid program in World War I. She also served as president of the YWCA and the Florence Crittendon Home, a refuge for unwed mothers. Daughter Lena stands on the front lawn of her family home. She is casually dressed, as the Carrolls, like most of the Carters, were somewhat relaxed with their children. The exception was Lillie Neuhaus Carter, wife of W. T. Jr., whose children's customary stiff attire often made them the butt of family pranks. (Above courtesy of Woodallen Photography– Houston; below courtesy of Sally Binz DeWalch.)

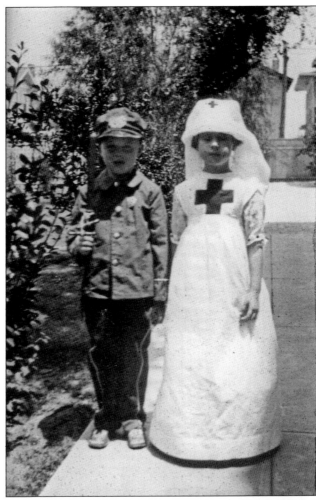

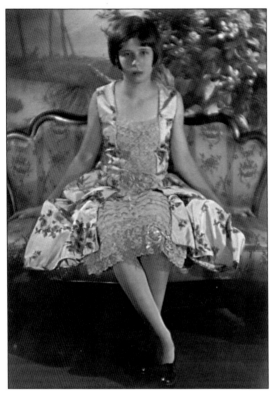

Lena, the youngest daughter, suffered from Bright's disease, a serious kidney ailment. She was pampered by the family and especially by her father, with whom she developed a close bond. His death at age 60 was devastating for her, according to Carroll granddaughters Susan Whiteford and Betsey Martin. Lena is pictured in a formal pose, perhaps at the time of her debut. A later informal photograph shows the three sisters, from left to right, Frankie Maude Carroll Bullington, Mary Josephine Carroll Kempner Reed, and Lena Carroll Anderson. Carroll grandson Denny Kempner recalls bringing friends home from work to visit his grandmother Lena, who had margaritas in the freezer in anticipation of his arrival. Everyone had a wonderful time, and at the end of the evening, Kempner "could barely get home" but grandmother was "still in good shape." (Both courtesy of Susan A. Whiteford.)

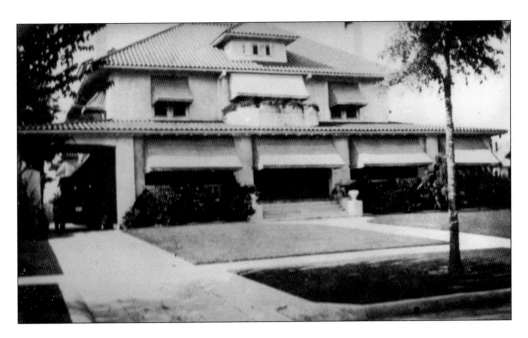

No. 18 Courtlandt Place, the second Carter family home on the boulevard, was completed in 1912 for W. T. Carter Jr. and Lillie Neuhaus Carter. Building in the Prairie style, architects Olle J. Lorehn and Birdsall Briscoe accentuated the home's horizontal planes with massive rectangular piers and a low-pitched, tiled roof. Concrete hitching posts carved with "C" flank its front walk, and magnificent fireplace mantels are each fashioned of a different wood. Carter's grandson Victor Carter II restored the house in the late 1970s. Victor Carter imported workmen from the mill at Camden, a few of whom had worked on the house for his grandfather. According to him, the lumber to build the house was milled in Camden, as was the lumber for most of the Courtlandt Place houses. (Both courtesy of Woodallen Photography–Houston.)

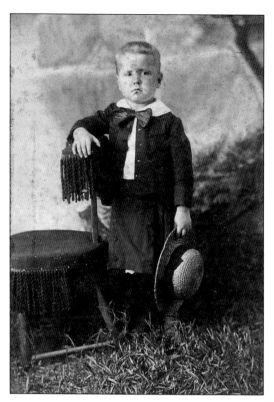

W. T. Carter Jr., "Bill," (1887—1957) was born to Ernest and Elizabeth Barclay Carter. Elizabeth died after his birth, and he was taken in by his paternal uncle, Will Carter, eventually adopted, and named William T. Carter Jr. In 1919, Will Carter relinquished oversight of his lumber operation to son Aubrey and directed banking and real estate concerns to Bill. Demonstrating the same drive and aptitude as his father/uncle, Bill built a commercial empire of 50 companies and developed powerful influence in Houston's civic, philanthropic, and social affairs. He was a port commissioner of the Port of Houston; served as a district councilman and councilman at large; and built Houston's first airport, which he sold to the city in 1937 (now Hobby Airport). (Above courtesy of Sally Binz DeWalch; below courtesy of Mary Carter Marold.)

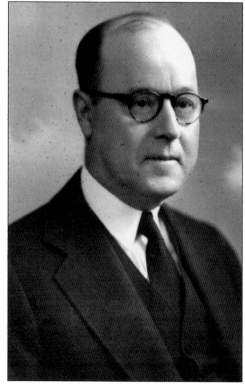

Bill Carter was a visionary businessman who abhorred any government interference in private enterprise. He was founder and president of Carter Investment Company, a vehicle to foster entrepreneurship and extend opportunity by providing loans to small start-up businesses. In the early 1950s, he foretold the gridlock that would result from freeways then under construction and conceived that video conferencing via electronic cable would be the future in business and education. He founded Phonoscope with the intent to wire cable throughout the entire city of Houston, and he and Jesse Jones hired technology expert Lee Cook away from the Los Alamos Project to help run the company. Unfortunately, Phonoscope's development would be limited first by competitor AT&T and then by federal government regulations. (Courtesy of Sally Binz DeWalch.)

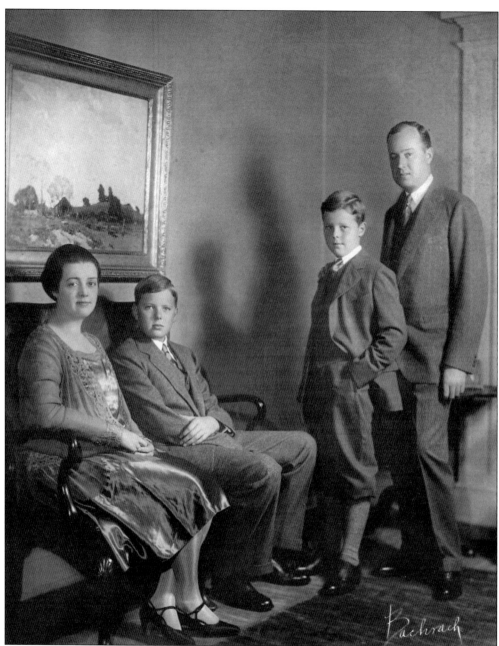

W. T. Carter Jr. and Lillie Neuhaus (1890–1966) married in 1910 and had two sons, Billy and Victor. Lil Carter, a niece of Charles Neuhaus of 6 Courtlandt Place, was a stern, imposing figure and ran a restrained household. She was demonstrably less laissez-faire than her Carter sisters-in-law. As intensely conservative as her husband, Lil was a powerful social arbiter of Houston's Old Guard. She and Bill wielded their influence as heads of the most powerful branch of a powerful family to limit entrance "into society" of the new oil money. Their purview included club memberships, in particular the Houston Country Club, as well as residency on Courtlandt Place. Ironically, her grandson Victor Carter II believes that his father Victor's marriage to oil heiress Betty Crotty was the first society wedding between old and new Houston. (Courtesy of Mary Carter Marold.)

Bill Carter died in 1957, and Victor Carter (right) inherited control of his companies. Billy Carter (below), called "Tall Bill" by the family, was only tangentially involved in the family business. Victor was a talented businessman who "could fix any problem and was willing to help everyone," according to Eleanor Howe, a contemporary. Victor and Lee Cook fought to lay Phonoscope cable wire across Houston 30 years before cable became commonplace. One of Phonoscope's investors was Bing Crosby, a technology-savvy businessman who helped develop the VCR. Aware of Crosby's interest in entertainment delivery systems, Henry King, musical director of the Shamrock Hotel, introduced him to Victor. Although Phonoscope's focus was on business communication, Crosby foresaw cable's potential in entertainment. He visited Houston frequently and exercised great influence on Phonoscope's development. (Both courtesy of Sara H. Stadeager-Andersen.)

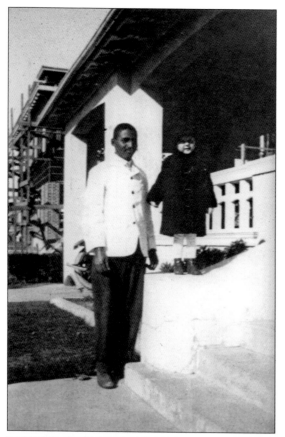

Pictured are most likely Victor Carter or his brother, Billy, and the adult is the Carters' butler. The boys are attired in none of the easy dress seen among their cousins and neighbors. A family tale relates that Frankie Carter Randolph once served the fastidiously dressed Billy with a trick cup that leaked and made him appear messy, much to his and his mother's dismay. Victor's son, Victor Carter II, recalls living with his mother's parents, the Crottys, when his father fought in World War II. According to Carter, his grandmother required peace in the evenings and instructed her butler to add rye whiskey to the grandchildren's after-dinner milk. Carter and the butler were great friends, and the butler confessed to him many years later. "So," said Carter, "this means I've been drinking since I was five." (Both courtesy Woodallen Photography–Houston.)

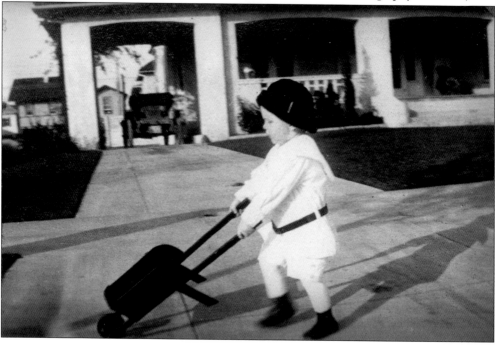

44

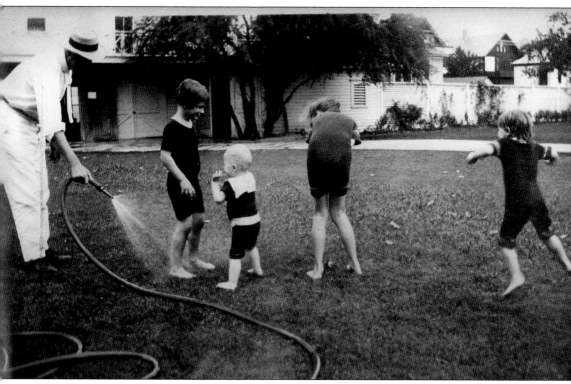

The adult tormenting the cavorting youngsters with the hose is Bill Carter. The children are believed to be, from left to right, Mary Carroll, Billy Carter (captured in unusually casual dress), Maudie Carroll, and a neighbor from No. 11, Nella Neville. Children roamed freely among the houses and had intimate relationships with the servants of the various households. Carroll granddaughters Susan Whiteford and Betsey Martin forged a particularly strong bond with the cook at No. 18, Daisy. Their vivid memories involve the pigeons that roosted there in a huge flock for 70 years. Bill welcomed the pigeons; they were one of his favorite meals. His manservant was instructed to shoot them, and Daisy would prepare a tasty meal to his liking. As children, Whiteford and Martin were horrified and entreated Daisy to stop "such a gruesome practice." Daisy promised to comply, but soon after, telltale feathered remains were found, and the two girls were devastated. In the 1990s, drastic measures were taken to rid the house of the messy intruders, but a hardy few still reside there today. (Courtesy of Woodallen Photography–Houston.)

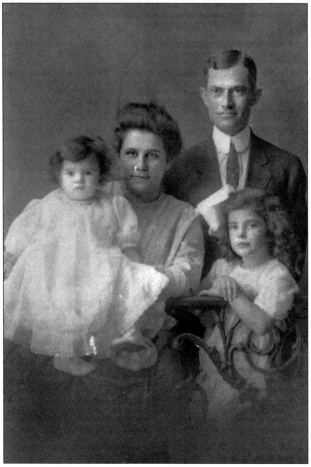

No. 20 Courtlandt Place, the third Carter home on the boulevard, was completed in 1916 by Birdsall Briscoe for Jessie Carter and Dr. Judson Taylor. The Taylors always had a houseful of guests. Visitors included Jessie's extensive coterie as well as Judson's patients, professional associates, and friends, notably Adm. Richard E. Byrd. Daughters Gertrude and Dorothy both experienced serious medical problems. Gertrude was born prematurely, and her physician father improvised an incubator from a shoebox and a light bulb. Dorothy suffered congenital foot deformities that required multiple surgeries and long convalescences throughout her childhood. As the orthopedic surgical skills necessary to treat Dorothy were unavailable in Houston at the time, the Taylors were fortunate to have Judson's connections and the means to seek treatment in Boston and Philadelphia. (Above courtesy of Woodallen Photography–Houston; below courtesy of Sally Binz DeWalch.)

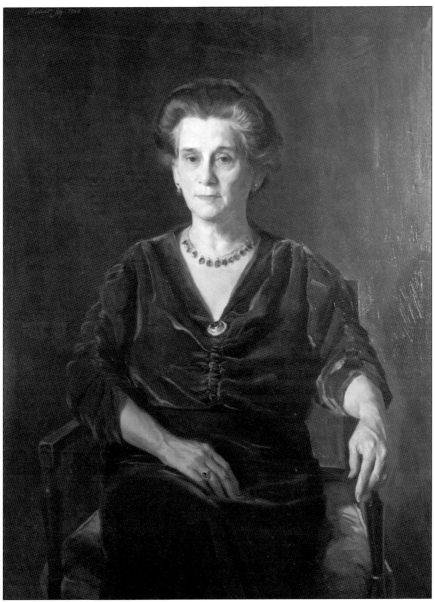

Jessie Carter Taylor (1881–1947) was generous to a fault and urged her husband to devote a significant amount of his medical practice to care for Houston's indigent. Jessie shared her sister Frankie Randolph's outlandish sense of humor and unconventional approach to life. Granddaughter Sally Binz DeWalch remembers the elaborate tricks organized by Jessie and Frankie at Camden, some of which were fairly rough fun. She recalls wearing a leather jacket with buckled sleeves on a trip home to Houston from Camden. Jessie couldn't resist buckling the arms together, which was probably funnier for Jessie than for granddaughter Sally. Jessie was a strong, fearless woman, and everyone knew it. After her husband's death, she slept with her gun, "Genevieve," under her pillow. Awakened one night by footsteps on Bill Carter's driveway next door, she called out and, receiving no reply, threatened to shoot. Bill quickly appeared to protect his early-morning hunting partner, who was unable to answer Jessie's challenge as his larynx had been removed. (Photograph by Benjamin Hill, courtesy of Sally Binz DeWalch.)

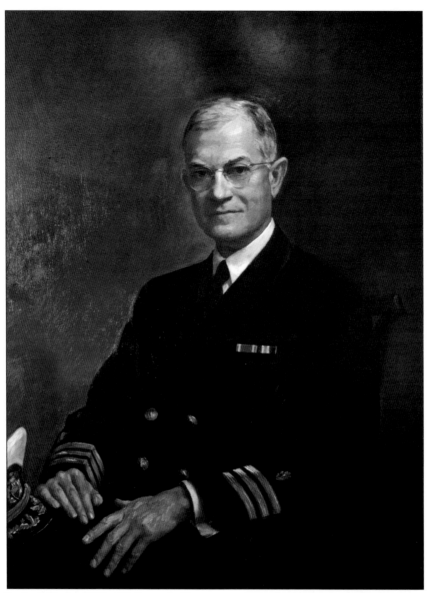

Judson Ludwell Taylor (1881–1944) married into a prominent family but established an outstanding reputation in his own right. After a highly successful U.S. Navy career, Judson started a private general surgery practice in Houston in 1912. Almost certainly in response to his younger daughter Dorothy's medical condition, he moved from general surgery to become Houston's first orthopedic surgeon, initially at Houston Shriners Hospital and later at Hermann Hospital and Jefferson Davis Hospital, Houston's first charity hospital, which he helped found. Judson's achievements included chief of the surgical department of Baylor College of Medicine; professor of oral surgery at Texas Dental College; founding member of the American Board of Surgery; and president of both the Harris County and Texas medical societies. Judson led in founding the first permanent blood bank for the Texas Gulf Coast and was instrumental, with sister-in-law Agnese Carter Nelms, in starting Houston's first birth control center. As a regent for the University of Texas, he influenced the decision to establish M. D. Anderson Hospital in Houston. (Photograph by Benjamin Hill, courtesy of Sally Binz DeWalch.)

The photograph of Jessie Carter as a youngster reveals much about her character and spirit. Note her insouciant stance, leaning casually on her elbow while staring directly and unflinchingly into the camera lens, completely unfazed by the proceeding. The photograph below celebrates a more sedate-looking Jessie, much as she would have appeared at the time of her marriage to Judson Taylor in 1903. Jessie, like her sister Frankie, knew the social graces, but her outlandish spirit was irrepressible and often asserted itself. (Both courtesy of Sally Binz DeWalch.)

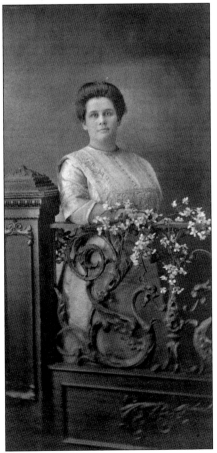

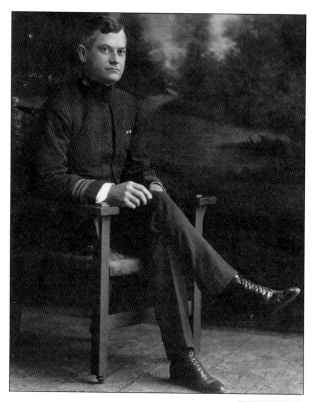

Judson Taylor graduated from the medical department of the University of Texas in 1903. Judson worked as house surgeon for the Gulf Coast and Santa Fe Railroad before joining the U.S. Navy, where he served in the Army of Cuban Pacification, 1906–1908. He retired in 1912 with the rank of commander and resumed his surgery practice in Houston. One of his legacies was Houston's first charity hospital, Jefferson Davis Hospital. After his death, the Board of Regents of the University of Texas resolved: "He was a just man. The extent of his services to the afflicted is known only to God, for Doctor Taylor moved about quietly." Granddaughter Sally Binz DeWalch describes him as a "sweet, loving man, gentle and humble. Patients' faces would light up when they heard him walk down the hall." (Both courtesy of Sally Binz DeWalch.)

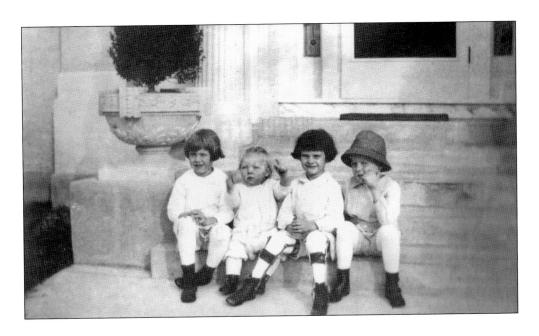

Above from left to right, Lena Carroll, Alice-Baker Jones of No. 22, Dorothy Taylor, and Billy Carter pose for the camera. Dorothy's braces are clearly visible but must not have inhibited her participation in the hurly-burly children's world of Courtlandt Place. Below, Dorothy and Alice-Baker appear again along with Gertrude Taylor, left rear, and Mary Carroll, far right. The name of the nursemaid at center is unknown. Courtlandt Place Boulevard's elliptical design, with generous sidewalks and a wide grassy esplanade, was an ideal campus for outdoor children's activities. Tina Cleveland Sharp, a grandchild of the Clevelands of 8 Courtlandt Place, asserted to Marguerite Johnston in *Houston: The Unknown City 1836–1946* that Courtlandt Place was known for "the best skating in town." It was an environment where children were free to roam without direct adult supervision. (Both courtesy of Woodallen Photography–Houston.)

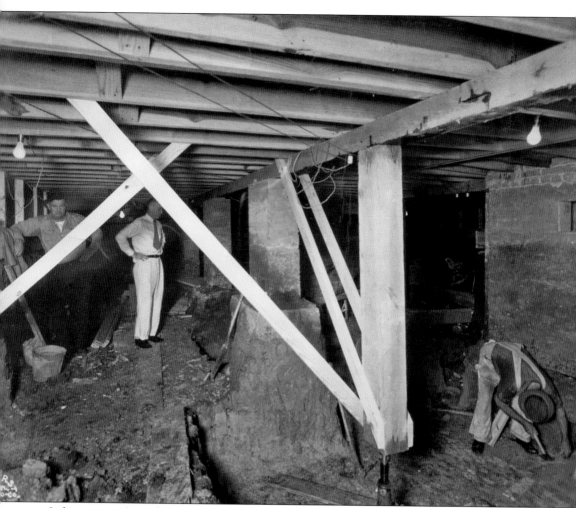

Judson was studious and soft-spoken; Jessie was a night owl who adored card games and gambling. During the 1930s, her children grown, Jessie expanded her basement to accommodate her consuming interest. Buckets of dirt were removed and support beams added until the cavity grew to meet the four corners of the house. Once it was completed, Jessie hosted relatively sedate card parties for lady friends during the week. More raucous activities ensued on the weekends, however. On Saturday nights and despite Prohibition, Jessie ran a gambling den complete with croupiers recruited from Jakie Freedman's South Main gambling houses, roulette wheels, and boxers imported from the Camden mill. Forty or 50 people usually attended. Jessie was in her element; Judson retired early. One may speculate that he picked his battles carefully. Victor Carter II recalls a practical joke played on Jessie, who so delighted in playing jokes on others. Family members engaged Houston police officers to "raid" the basement one Saturday night, scaring everyone to death. (Photograph by Benjamin Hill, courtesy of Sallie Binz DeWalch.)

Three

KING COTTON

The energy-driven Houston of the early 21st century would hardly recognize the Houston of 100 years ago. That Houston was very much a Southern city, and cotton, as in most of the states of the Old Confederacy, was a leading industry. After the Civil War, railroad expansion to the west and soil exhaustion on the cotton lands east of the Mississippi River pushed legions of cotton farmers to Texas. In 1919, cotton prices hit the highest price per pound to date, and Texas rivaled Mississippi and Georgia in production. By 1926, Texas was producing 40 percent of all domestic cotton; Houston was its distribution hub to the railroads and to the ocean-plying cargo ships waiting in the Houston Ship Channel.

Most cotton farmers in the South didn't get rich, but cotton factors did. Some of the wealthiest and most established made their homes on Courtlandt Place, and their lifestyles lacked few luxuries. By 1910, cotton was a global commodity traded on the stock exchanges. At least two of the Courtlandt Place factors, John Dorrance and Edwin Neville, traveled extensively to Russia, Asia, and the Near East on business at a time when even first-class international travel was still difficult, lengthy, and often dangerous.

The 1920s were a period of upheaval in American life. The Great Depression was preceded by a devastating agricultural panic, and cotton shares tumbled, knocking the American cotton industry to its knees. And as the robber barons and Wall Street financiers would experience in short order, wealthy cotton factors saw great portions of their wealth vanish overnight.

On Courtlandt Place, Edwin Neville, John Dorrance, and Wanroy Garrow maintained their privileged lifestyles but responded individually to the crisis that decimated their businesses. Neville kept his firm but successfully changed his focus from cotton to banking; Dorrance stayed the course, and his son John K. Dorrance eventually recouped some of their fortune in the oil fields. Garrow was less resilient; he closed his brokerage and retired while still in his early 40s.

King Cotton was dead; long live King Oil.

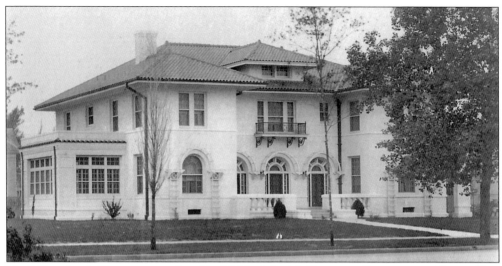

No. 9 Courtlandt Place was completed in 1914 for John M. Dorrance. Sanguinet and Staats, Fort Worth architects with a Houston office, referred to their design as "California Style." The daring Latin-inspired buildings of the Panama-California Exhibition being erected in San Diego to celebrate the completion of the Panama Canal were causing a sensation, and Mediterranean-style houses were springing up across the country. The Dorrance home offers the most pronounced interpretation of the genre among the original structures on Courtlandt Place. It was built for lavish entertainments with an enormous reception hall instead of a conventional living room. A mirror at the turn of the grand staircase bears a watermark from the 1900 Galveston hurricane. Typical of Courtlandt Place connections, one of Dorrance's business partners, Edwin Neville, built his family's home next door. (Both courtesy of Bonner Sewell Ball.)

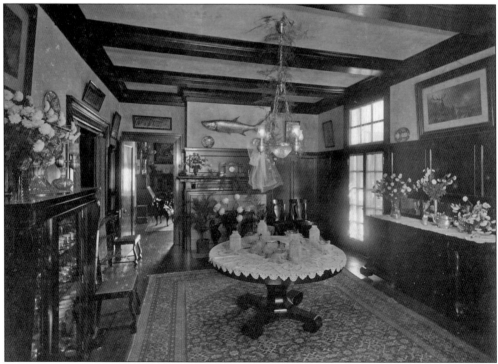

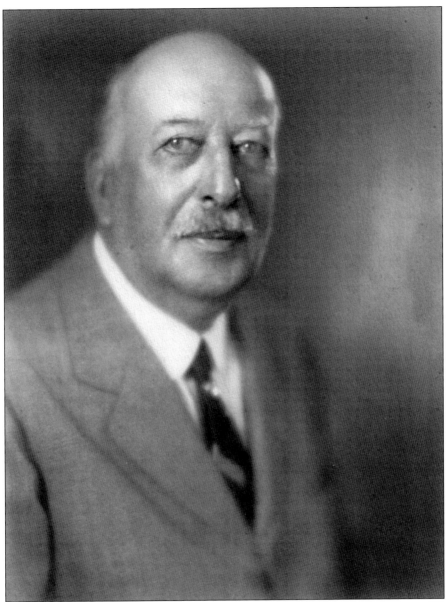

John M. Dorrance (1852–1935) was born in Massachusetts and came to Houston in 1891. He worked for H. W. Garrow and Company and opened Dorrance and Company in 1897. "Dorco" became one of the most important cotton firms in the South with offices in Houston and Milan. John frequently traveled on business and pleasure, often with family in tow. Granddaughter Peggy Dorrance Powers recalled his cultivated taste and exquisite manners. John admired a chic blue Easter ensemble worn by the wife of a Milanese business associate and presented the lady with an equally stylish blue hat. A "cotton man" for over 60 years, John was a vice president of the Houston Cotton Exchange and president of Shippers Compress Company. He had extensive mercantile, banking, and real estate interests and built the Dorrance Building at 114½ Main Street as well as the Savoy apartment hotel. Despite occasionally bestowing $100 on Hugh Roy Cullen, "King of the Wildcatters," who often stood on Main Street looking for investors, John had no faith—and no luck—in oil. (Courtesy of Bonner Sewell Ball.)

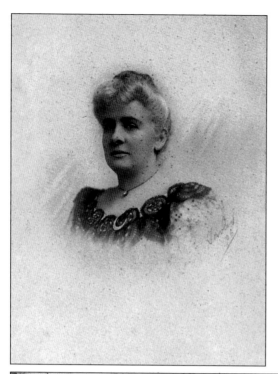

Ada Knapp Dorrance (1860–1933) was born to a prominent Catholic family in St. Louis. The Dorrances maintained a lavish lifestyle, employing a cook, laundress, chauffeur-butler, housemaid, and Ada's lady's maid, Patty. Granddaughter Peggy Dorrance Powers recalled staying with Ada and being entrusted to Patty's care. The Dorrances belonged to all the best clubs and, despite setbacks in the cotton industry and the ensuing Great Depression, lived with few economies. A recipe for Mock Turtle or Calves Head soup from Ada's cookbook, written in her hand, illustrates the elaborate nature of many dishes prepared for her table, presumably by the cook. Rather off-putting today, it calls for "a large head cleaned nicely . . . boil till the flesh is quite tender . . . take the eyes out carefully." (Above courtesy of Bonner Sewell Ball; below photograph by Benjamin Hill, courtesy of Peggy Dorrance Powers.)

Mock Turtle or Calves-head Soup—
Mrs. Thomas—

Have a large head cleaned nicely without taking off the skin. divide the chop from front of the head, take out the tongue— Put the head to boil in one gal of water, with several small onions, thyme, parsley, tea-spoonful cloves, mace, pepper, salt & a little cayenne pepper. Boil till the flesh is quite tender on the head; take it out & cut into small pieces - take the eyes out carefully, strain the water in which it was boiled, pick all the strings from the brains, pound them and add grated bread, pepper & salt make into small round balls with the yolk of one egg - fry a nice brown - Boil several eggs hard & cut fine - place in the Tureen with some wine and walnut pickles or catsup, and a lemon sliced. After straining the broth put back meat & thicken with the brown flour, 2 tablespoonful mixed with one

half lb of Butter, throw in fried brain Balls just before serving up in Tureen

John and Ada Dorrance had four children, Virginia, John K., Margery ("Peg"), and George. George (right) served as a flier in the U.S. Army in World War I and then joined John K. and their father in the cotton business. George worked in Dorco's Milan office in the 1920s, and his young family lived abroad for several years. Peggy Dorrance Powers, George's daughter, spoke fluent Italian and little English at age four. She describes her father as "a dreamer." John K. Dorrance, who succeeded his father as head of Dorco, married later in life, became highly successful in the oil business in the 1930s, and was president of the Tejas Club. (Above courtesy of Peggy Dorrance Powers; below courtesy of Bonner Sewell Ball.)

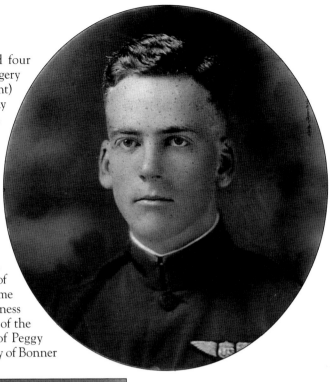

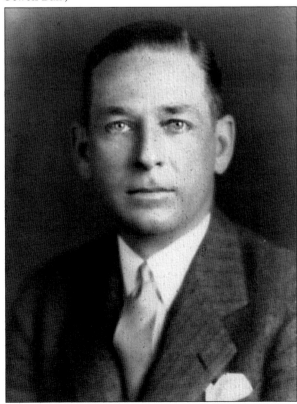

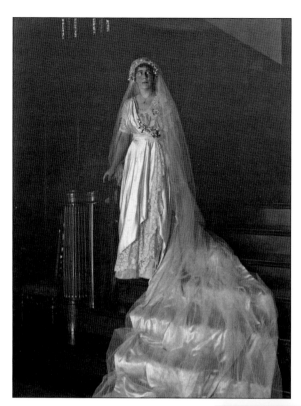

Ada Dorrance remained a devout Catholic all of her life and was unhappy that Virginia—or any of her other children—failed to marry a Roman Catholic. According to granddaughters Bonner Sewell Ball and Virginia Sewell, Virginia was sweet, religious, and quiet, overshadowed by her more outgoing sister Peg. A letter from her father, John Dorrance, written shortly after her marriage to Don Hall in 1915, is revealing: "I have thought of you each and every day since the night you left your Old House. . . . No one to look after your old Dad now. He is getting old and no one cares for him like you do—I let you leave me because it was for your Happiness. . . . I hope your life will always be one Bright Star without clouds." (Above courtesy of Bonner Sewell Ball; below courtesy of Peggy Dorrance Powers.)

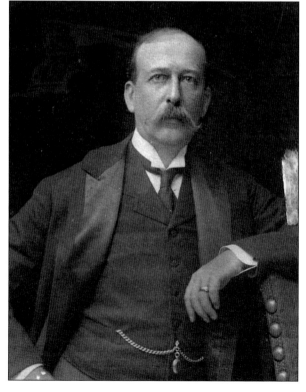

Margery ("Peg") Dorrance was a beautiful, captivating woman who, like her brother John, married later in life. The picture at right shows Peg and an unidentified companion in Piazza San Marco, Venice. An outstanding golfer, Peg won the 1925 Texas Women's Golf Championship held at the Houston Country Club. She was an accomplished equestrienne, an interest she shared with her husband, Cecil Wilfong, whom she married in the early 1930s despite her parents' disapproval. Within two years of the marriage, Wilfong fell from his pony during a polo match and died. Margery was almost impoverished after his death and moved back to the Dorrance home. In later years, she had a small china shop in the first Houston Junior League building. When the family sold 9 Courtlandt Place in 1941, the proceeds went to Peg. (Both courtesy of Bonner Sewell Ball.)

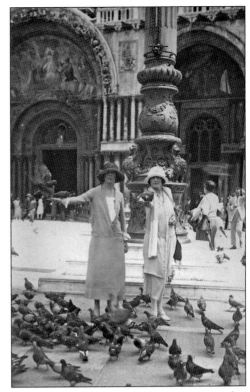

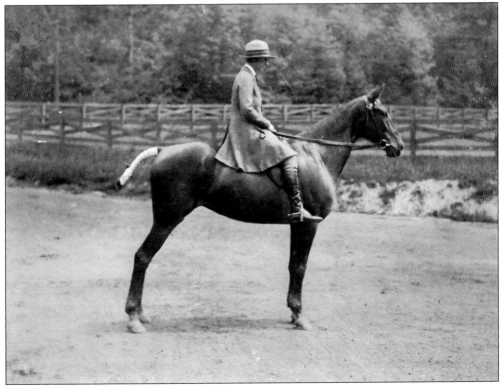

No. 11 Courtlandt Place and its gardens were completed in 1914 by Birdsall Briscoe for Edwin and Daphne Neville. In contrast to the Mediterranean and Georgian Revival influences of other Briscoe homes on the boulevard, the Neville residence exhibits Tudor Revival elements. The house boasted one of the first central vacuum systems and a rudimentary electric refrigerator. The Nevilles were an extremely sophisticated family with refined tastes. Their wedding reception, below, held in Daphne Neville's parents' home, offered a glimpse of the rich display that surrounded the young couple from the beginning of their life together. Daphne's grandfather was Benjamin Shepherd, Houston's pre-eminent banker from before the Civil War until his death in 1891. Edwin Neville later became chairman and major stockholder in his grandfather-in-law's bank, First National Bank, for many years called "Shepherd's Bank." (Both courtesy of the Letzerich family.)

Edwin Linscott Neville (1879–1937), "Ned," was born in Portsmouth, Virginia. The lingering aftermath of the Civil War and Radical Reconstruction caused many Virginians, including Ned, to seek their fortunes in Texas, where Reconstruction had been brief and relatively benign. Ned arrived in Houston in 1896 and became a partner in the cotton factorage of Dorrance, Neville, and Cairns in 1897. An astute businessman with international scope, Ned traveled the world negotiating cotton purchases. He subscribed to at least four newspapers from around the country and scanned them every morning before leaving for his office. When cotton markets tumbled in the 1920s, Ned was already invested in bank shares as well as other businesses. In the Great Depression, the Nevilles pledged enough bank stock and cotton certificates to guarantee the survival of First National Bank. (Both courtesy of the Letzerich family.)

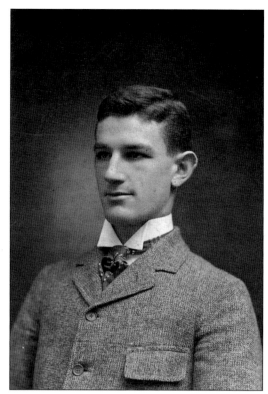

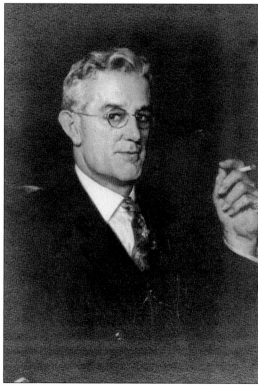

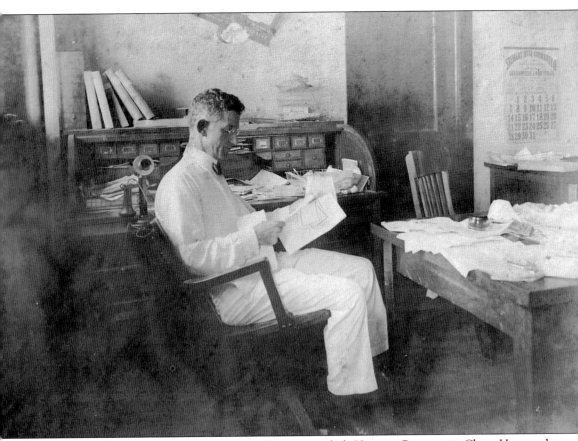

Ned Neville was heavily engaged in civic affairs, particularly Houston Community Chest. He served as assistant State Food Administrator during World War I, which he described as "the hardest job I ever had," and later as chairman of the board of directors of Jefferson Davis Hospital. An early supporter of the Kinkaid School, Ned was instrumental in moving the campus from Margaret Kinkaid's home to a larger Montrose location. He was an avid sportsman whose greatest pleasures were golf, hunting, and fishing. Ned caught tarpon in Aransas Pass, a favorite spot of sportsman Franklin Roosevelt, and helped found the Eagle Lake Rod and Gun Club. Club members caught the westbound Southern Pacific train on Friday afternoons in Bellaire and rode 50 miles to the rice marshes of Eagle Lake, making the return trip on the eastbound train on Sunday evenings. Ned died in his sleep at Eagle Lake and was eulogized in Palmer Memorial Episcopal Church as "A Virginia Cavalier of the Old South, [who] developed a great pride and interest in Texas, his adopted state." (Courtesy of the Letzerich family.)

Daphne Palmer Neville (1879–1949) was born
into wealth and privilege. She lacked nothing,
except perhaps happiness. As one of Houston's
most admired debutantes, her 1912 marriage
to Ned Neville received four columns of
fawning prose in the newspaper society section.
They honeymooned in Japan, and, as Ned's
business prospered, Daphne, despite a heart
condition, accompanied him on his travels
and purchased superb furnishings and art for
their home on Courtlandt Place. Daphne was
a founder of the Junior League of Houston
and a major benefactor of Rice Institute. In
1927, she donated $100,000 for the Edward
Albert Palmer Memorial Chapel in honor of
her brother, whose tragic death as a young
man must have haunted her. After the death
of her younger daughter, she gave the Elizabeth
Neville Wood Memorial Cloister to St. John's
School. (Both courtesy of the Letzerich family.)

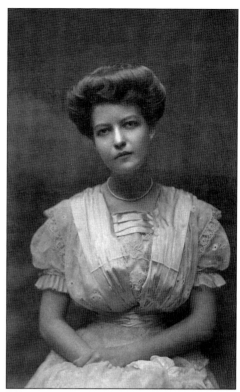

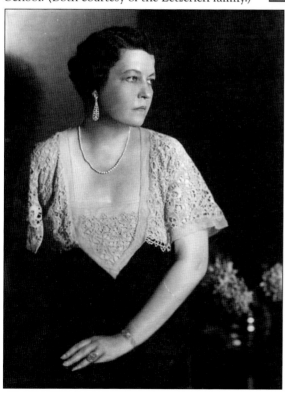

Edward Palmer was a Princeton graduate beginning a career with First National Bank. One evening in 1908, he and sister Daphne joined a boating party sailing from Clear Lake to Galveston Bay. Daphne fell overboard, and several young men, including Ned Neville and Edward, dived to her rescue. Daphne was hauled in, hilarity ensued, and the party sailed on when someone realized Edward was missing. He had drowned. William Ward Watkin and John Staub, working for the Boston firm of Cram and Ferguson, designed Edward's memorial. Daphne specified that it be predicated on Venice's 15th-century Santa Maria dei Miracoli. Now Palmer Memorial Episcopal Church, it and Autry House form an integral part of the South Main Street environment, Houston's sole manifestation of the City Beautiful urban reform movement. (Above courtesy of the Letzerich family; below courtesy of Palmer Memorial Episcopal Church.)

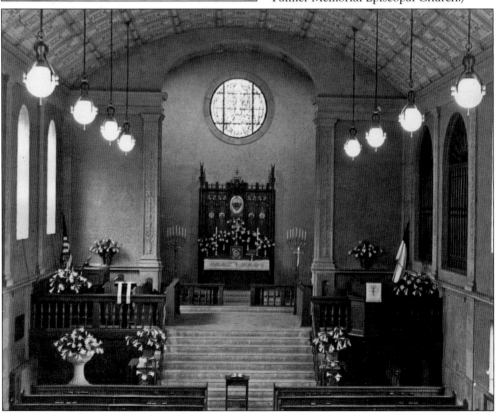

Daphne's younger daughter Elizabeth Neville Wood was stunningly beautiful but shared her mother's heart condition. Despite physical frailty, Elizabeth married in Palmer Memorial Chapel and had two children. Her early death at age 27 was the second pall cast over Daphne's life. The Neville daughters enjoyed a privileged lifestyle on Courtlandt Place but were left for long periods with the household staff when their parents traveled on business. In summer, the family traveled for pleasure and decamped to Europe or Peckett's Inn near Franconia, New Hampshire. Peckett's catered to a mix of old and new money, including Hollywood star Bette Davis. Its famous ski runs were designed by White Russian aristocrat Duke Dimitri of Leuchtenberg. The Nevilles arrived by train with a few servants and their Pierce Arrow car and were met by their summer chauffeur. (Both courtesy of the Letzerich family.)

Older sister Nella Neville Letzerich inherited both her mother's striking looks and her melancholic, often difficult temperament. Both mother and daughter were stern, unyielding, adhering strictly to the social conventions of the elite. Daphne ruled with an iron will. She breakfasted abed each morning; in the evening, family and guests gathered in the parlor before proceeding to the dining room. Those under age 12 ate with the staff in the breakfast room, and all children were banished to the second floor after dinner. The adult Nella also insisted on strict propriety and formality. Nella's sons, Louis and Ned Letzerich, wryly recall "the pusher," an infamous silver device omnipresent at every child's place at table to insure that hands and food never touched. (Both courtesy of the Letzerich family.)

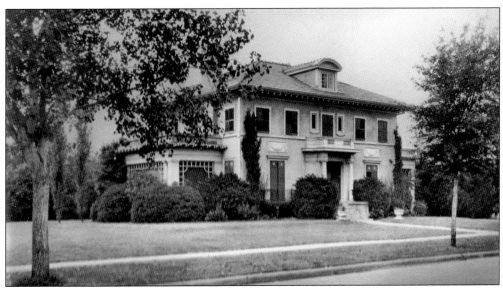

No. 19 Courtlandt Place was completed in 1913 by Birdsall Briscoe for John Wanroy Garrow. Its distinctive Georgian Revival/Mediterranean facade was featured in *The Architectural Record of 1915*. The house held a personal association for Briscoe; he served as groomsman when Wanroy Garrow married Marie Etta Brady in 1908. Briscoe was exacting and meticulous. In a letter to the general contractor, he unfurled an exhaustive list of incomplete and unsatisfactory items. His extreme frustration was palpable, and he scribbled additional complaints in the margins. Briscoe concluded, "I would suggest that you give these matters your personal attention. The Owner has grown impatient, and has just cause to be impatient, for the job has dragged along in a very unsatisfactory manner for the past several weeks." (Above courtesy of Woodallen Photography–Houston; below photograph by Benjamin Hill, courtesy of the Gordon-Schwenke family.)

B. P. BRISCOE
ARCHITECT
No. 333 COMMERCIAL NATIONAL BANK BUILDING
HOUSTON, TEXAS : TELEPHONE PRESTON 4074

28. The baluster rail of the main stairs does not seem to have a sufficient number of coats. It does not compare at all with other work of this character. Another coat should be applied and then rubbed to make it grade up with other work.

29. Wood trim on second floor of garage has not been painted as specified, see page 30. The painter must see the owner and find out what color he wants this work painted.

Many of the items to which I have previously called your attention have not yet been corrected and made good. I would suggest that you give these matters at once your personal attention. The Owner has grown very impatient, and has just cause to be impatient, for the job has dragged along in a very unsatisfactory manner for the past several weeks.

I am, very truly yours,

Some of the enamelled sills on second floor show discoloration spots by exposure to weather.

Paper in owners bedroom torn above wall lights

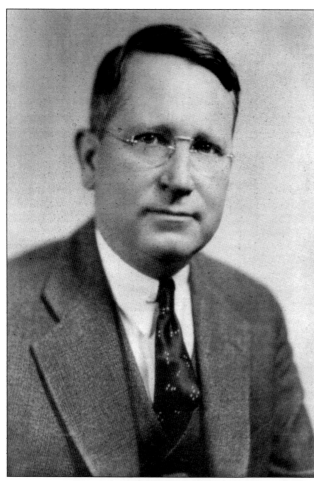

J. Wanroy Garrow (1879–1944) was the son of H. W. Garrow, whose cotton factorage was one of the South's most prosperous. After the cotton markets collapsed, Wanroy, in his early 40s, did not overhaul the family firm or transition to oil or banking. Bowing to reversal of fortune, he "retired." Despite restricted finances, Wanroy stayed with what he knew, serving as president of the Houston Cotton Exchange and becoming a cotton lobbyist. He met Pres. Franklin Roosevelt, whose policies he faulted for depressed cotton prices, but reported that he never felt he had the president's attention. Wanroy was a director of the chamber of commerce, American General Insurance Company, Navarro Oil Company, and Houston Farms Development. Houston Farms yielded his family much welcome oil revenue after his death. (Above courtesy of Elsa Perlitz Hudson; below courtesy of Woodallen Photography–Houston.)

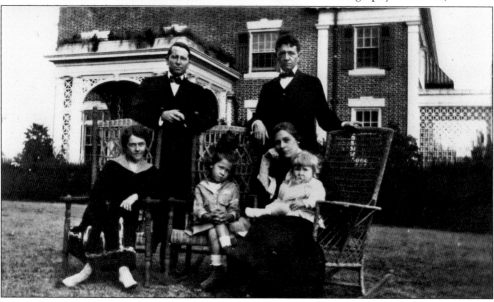

Marie Etta Brady Garrow, "Etta," (1887–1941) was a daughter of John Brady, named by the *Houston Post* in 1922 as "one of the wealthiest men in the country" prior to 1900. He was an organizer of the Houston Ship Channel Company, one of Houston's largest real estate developers, and president of Magnolia Park Railway. Etta's wedding to Wanroy took place at her family's baronial mansion. A paean in the *Houston Post* gushed over "the prominence and popularity of the bride and bridegroom." Even so, a childhood bout of rheumatic fever left Etta with a weakened heart, and her condition asserted itself as she bore three children and grew older. Perhaps because of Etta's condition, the Garrows entertained infrequently, although economy may also have played a role. (Above courtesy Elsa Perlitz Hudson; below courtesy of Woodallen Photography–Houston.)

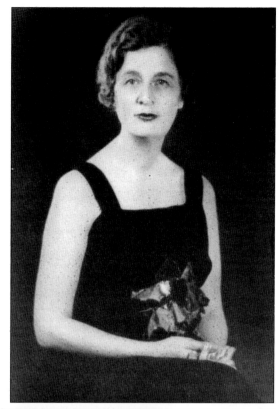

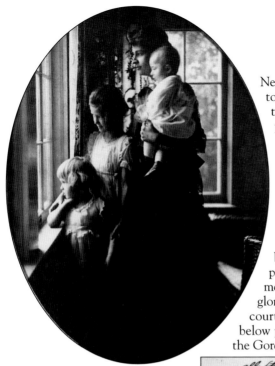

Neither Etta nor Wanroy had the life experience to prepare for the turn their lives would take. Perhaps Wanroy had a melancholy presentiment when, on a contented Christmas night in 1914, he penned an elegiac entry in his journal titled "Lest We Forget." A portion reads, "Surely before many years have passed there will be more than one broken link in the chain of our family life. May we not then be cowards and may we use on other Christmas days the armor of todays [sic] delight and may the peace of what has been guide us through the din and pledge us promise of what is to be, a happy home once more restoring us transfigured perchance, yet glorified although with death allied." (Above courtesy of Woodallen Photography–Houston; below photograph by Benjamin Hill, courtesy of the Gordon-Schwenke family.)

The Garrows had three children, Estelle, Gwendolyn, and J. W. Jr., called "Double." Double is pictured in a goat cart, which probably belonged to the photographer. After the cotton crash and through the Great Depression, Etta and Wanroy "kept up appearances" and retained memberships in the city's best clubs, including the Houston and River Oaks country clubs, the Thalian Club, and the Paul Jones Dance Club. The family made extended summer visits to Winslow, Arkansas, in the Ozark Mountains, where they had a cabin, as did other Houston families. Etta and Wanroy were devoted to one another and their children. After Etta died, grandson Charles Perlitz remembers seeing his grandfather burst into tears upon unexpectedly discovering a photograph of his wife. (Above courtesy of the Gordon-Schwenke family; below courtesy of Woodallen Photography–Houston.)

Estelle Garrow's bridal portrait is taken before the Garrows' living room fireplace. Estelle's wedding to Charles Perlitz Jr. on April 23, 1930, engendered reams of newspaper print: "Palms and tall silver vases of Easter lilies ornamented the altar space, and ivory tapers burned in cathedral candelabra. . . . After the ceremony, a wedding breakfast was served at the home of the bride's parents. A lace cloth over green satin graced the dining table, which was centered with a bride's cake, embossed with roses. . . . Mr. and Mrs. Perlitz left for a 10 days' wedding trip to Mexico City. The latter traveling in a smart black and beige wool and crepe ensemble, with beige broadtail collar, and black Panamalac [sic] hat, trimmed in beige." Subdued reporting compared to the Edwardian prose detailing her parents' nuptials 22 years earlier: "the beauty and artistic details of the occasion, and the splendid hospitality expressed, conspired to make the marriage one of the most important nuptial events recorded in the social history of the city. . . . The decorations of the home were notably chic and smart." (Courtesy Woodallen Photography–Houston.)

Four

OIL

Oil was the single resource that defined the 20th century in America. The first well was drilled in Titusville, Pennsylvania, before the Civil War, and by 1900, oil had fueled fortunes, including the immense wealth of John D. Rockefeller. The oil fields of Pennsylvania coal country produced kerosene to light the world's lamps and replace scarce, expensive whale oil; gasoline was a nuisance byproduct. The technology did not exist to harness its potential, but as the new century dawned, the unexplored possibilities of oil drove invention. These coaxial forces ignited in the rocky crucible of the Northern oil fields and exploded far to the south, in Texas.

Water-well drillers tapped the first Texas oil by accident in Corsicana in 1894. But that field was dwarfed six years later by the spectacular eruption from a well drilled through the shifting sands of a salt dome near Beaumont. Known as Spindletop, its production approached 100,000 barrels per day and became the foundation of the predecessor to Gulf Oil Corporation.

A remarkable cluster of oil hunters who would change the world descended on Beaumont. One of the first to arrive was Joseph S. Cullinan. A roughneck from Pennsylvania who had been operating wells in Corsicana, the charismatic Cullinan attracted risk-takers willing to brave terrible working conditions, worse food, and personal danger. He not only wanted to refine oil already gushing from the ground and sell it but explore for more, a chancy undertaking. He brought in two men from Corsicana who would prove instrumental in his success: accountant and businessman Thomas J. Donoghue and attorney "Judge" James L. Autry. In 1902, Cullinan's Texas Company, later Texaco, was chartered with both men as directors and Autry as general counsel.

The United States' oil capital shifted from Titusville to Beaumont overnight and shifted again, permanently this time, to the rail hub of Houston. Cullinan, ever the trailblazer, established a Private Place oil fiefdom in Shadyside, but Donoghue, Autry, and Underwood Nazro, a vice president of Gulf Oil, chose to live among the lumber barons and cotton kings of Courtlandt Place.

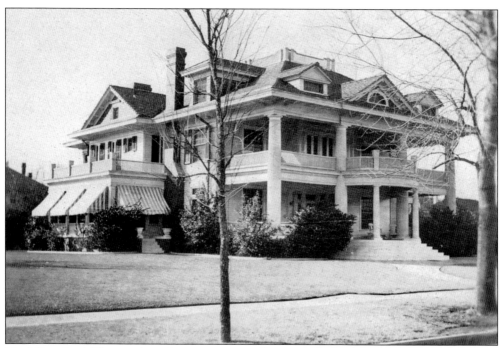

No. 5 Courtlandt Place, perhaps the most recognized home on the boulevard, was completed in 1913 for Judge James and Allie Autry by Sanguinet and Staats. The facade of the Neoclassical Revival home exhibits a distinctly antebellum flavor, while interiors reflect Arts and Crafts influence with integrated rooms, rich paneling, beamed ceilings, and leaded beveled glass. Autry, director and general counsel of the Texas Company, instructed the architects to predicate the house on one he admired in Corsicana. No detail escaped his scrutiny; he closely monitored construction costs, which, according to correspondence, were $40,686, a considerable sum in 1913 dollars. Like the Neville house, it boasted a central vacuum system as well as a built-in icebox with an exterior door for ice deliveries. (Both courtesy of Woodson Research Center.)

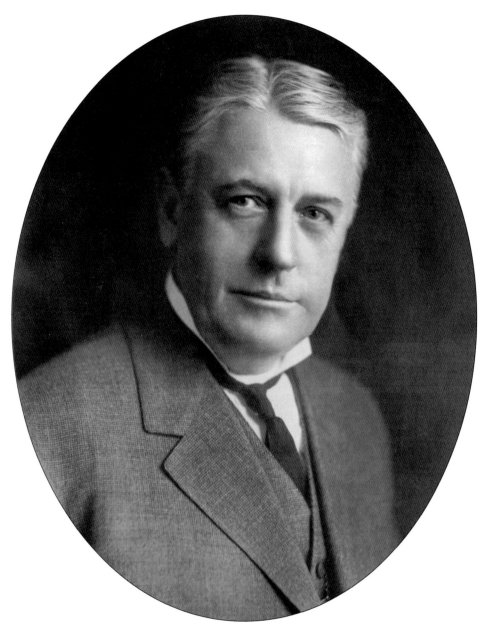

James Lockhart Autry, "Judge," (1859–1920) was a principal architect of oil and gas law in Texas, a founder of the State Bar of Texas, an author of the State Bar of Texas Code of Ethics, and a member of the State Bar of Texas Professional Ethics Committee. Judge was born in Mississippi, but his destiny lay with Texas and oil. He curtailed studies at the University of the South to manage his family's ranch near Corsicana. The land was a Republic of Texas bounty grant earned by his grandfather, who fought for Texas independence and died at the Alamo. Young James began legal studies in Corsicana, was admitted to the bar in 1880, and served briefly as Navarro County judge. Judge was an established figure in Corsicana when J. S. Cullinan arrived after the discovery of oil in 1894. Cullinan hired him to file the charter for his Texas Fuel Company, and when Cullinan shifted operations to Spindletop, Judge went with him. Their lifelong partnership through several companies made them rich men. (Courtesy of Woodson Research Center.)

January 4, 1914.

Mr. Sterling Myer,
 Houston, Texas.

Dear Sir:

Please pardon my oversight in not having sent you the $55.00 before this time, and I enclose it here-with.

I am still of opinion that Courtlandt people are very derelict in not having a meeting of Trustees and properly organizing them and making provision for an authoritative management of affairs and pitching the same upon a higher and better plane of efficiency than has heretofore obtained. I think we should either do something of the kind or turn our property over to the City.

 Very truly yours,

JLA-e
Enclosure (Signed) JAS. L. AUTRY.

Judge was a Courtlandt Place trustee, having shrewdly purchased one share of stock in the Courtlandt Improvement Company. A stickler for clear, precise detail, he demanded the same of others but was frequently disappointed in his Courtlandt Place neighbors. The loose ends and unknowns Judge perceived in his fellow trustees' management style irritated him. His attorney's mind constantly "tested the fences," and he was accustomed to winning. In 1915, Judge purchased the lot next door and planned to construct a greenhouse, gardener's cottage, and tennis court. He petitioned the trustees for a deed modification to allow the tennis court and a tall fence to encroach the front building line. They refused, much to his consternation, a decision that stiffened the deed restrictions and set an important precedent for future challenges. (Above courtesy of Woodson Research Center; below photograph by Benjamin Hill.)

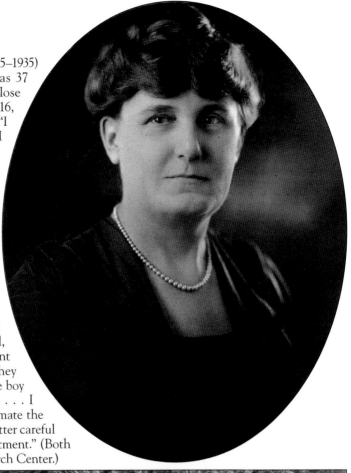

Allie Belle Kinsloe Autry (1875–1935) married Judge when he was 37 and she 21. Theirs was a close marriage; Judge wrote in 1916, their 20th anniversary year, "I cannot tell you how much I love you and how essential your presence is to my comfort and contentment." His tenderness extended to his widowed mother, with whom he was unusually close and who lived with him until her death, and to his children, James Lockhart III ("Jimmie"), and Allie May ("Sally"), of whom he was extremely protective. When Jimmie felt unwell and was sent home from school, Judge misunderstood and sent a note to the principal, "They telephoned me that my little boy had returned from school. . . . I hope you will not underestimate the importance of giving the matter careful attention and judicious treatment." (Both courtesy of Woodson Research Center.)

The Autrys indulged in the trappings of wealth and power. Daughter Sally's wedding photograph was taken by the Harris and Ewing Studio of Washington, D.C., famous for presidential portraits. The Autrys lived very well, even by Courtlandt Place standards. Household records reveal frequent orders of seafood shipped by rail from Massachusetts. The family traveled extensively for pleasure, with Judge characteristically planning the journeys in exhausting detail. Judge was an automobile enthusiast and shipped his Winton car to his destinations, where he engaged local chauffeurs. A car ahead of its time, the Winton was the brainchild of a brilliant but short-tempered Scotsman in Ohio whose perfectionism extended to refusing to hire Henry Ford. It was the perfect car for the exacting Judge, who furnished his chauffeurs with three pages of comprehensive instructions. (Both courtesy of Woodson Research Center.)

Lucy Waller ("Tap") joined the Autry household as a young woman in Corsicana and moved with them to Courtlandt Place. Tap was a beloved retainer, and young Jimmie was the apple of her eye. In 1916, she died after contracting pneumonia waiting in the rain at the trolley stop to make sure Jimmie wore his raincoat. The Autrys were prostrate with grief and held Tap's funeral in their parlor with the rector of Christ Church officiating. According to the extraordinary and extremely poignant newspaper coverage of the service, Jimmie and five of his friends were pallbearers. On the afternoon of her death, Tap dictated her last will and testament to Judge and left all of her worldly goods to Jimmie. She authenticated the short document with her mark; Tap was illiterate. (Both courtesy of Woodson Research Center.)

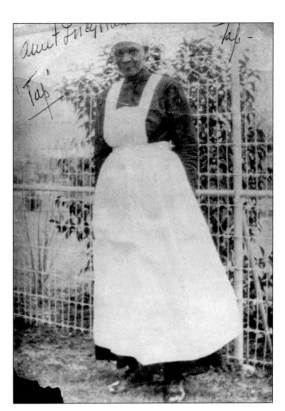

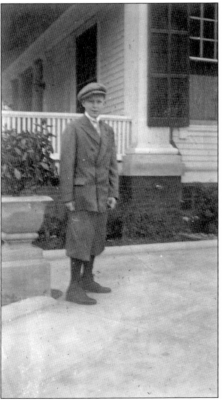

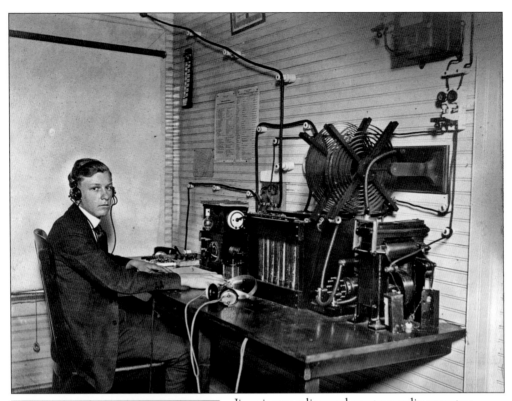

Jimmie was a licensed amateur radio operator. According to a newspaper article, he and five other teenagers called themselves the Houston Radio Club. The article attributed the "largest and strongest" of the five wireless plants to Jimmie. World War I was raging in Europe, and most assumed that America would join the fight. Jimmie arranged to alert Courtlandt Place with a single pistol shot when war was declared. On the morning of April 6, 1917, Jimmie fired his pistol; on April 7, civilian radio activities were suspended, and the radio industry was taken over by the government for the duration of the war. Jimmie graduated with honors from Rice Institute and entered a promising career in the oil business. Six weeks before his wedding day in 1922, he died tragically of appendicitis. He was 23. (Both courtesy of Woodson Research Center.)

From 1907 until his death in 1920, Judge was not a well man. He suffered from a debilitating bowel ailment, which was compounded by a stroke in 1915. Judge sought medical relief around the country, but despite several surgeries, results were unimpressive. He soldiered on, continuing to be active in his demanding business while enduring chronic pain. After his death, his family donated Autry House (below) in 1921 as a new student center for Rice Institute to replace an existing structure (above). Autry House was designed in the Venetian Revival style by William Ward Watkin working with John Staub. Watkin substantially modified a plan by architects Cram and Ferguson of Boston, as he would again six years later for Palmer Memorial Chapel. (Both courtesy of Woodson Research Center.)

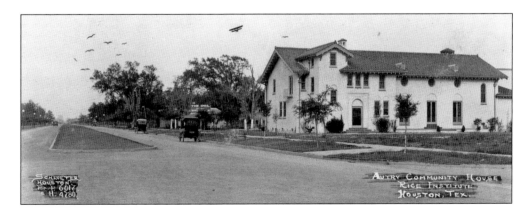

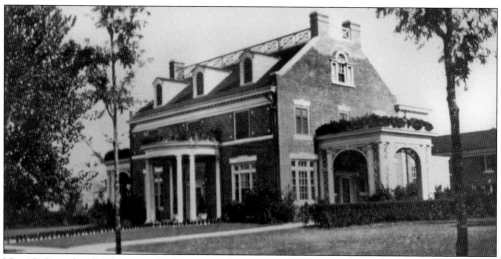

No. 17 Courtlandt Place was built in 1916 for T. J. Donoghue, a director and vice president of the Texas Company, and his wife, Mamie Sullivan. It was designed by Warren and Wetmore, the New York architectural firm famous for designing Grand Central Station in New York who also designed the Texas Company building on Rusk Street in downtown Houston. The Donoghue residence was their only residential commission in Houston and the first home in the city designed by an out-of-state architect. The house is constructed of red brick in the Georgian Revival style with robust white details, an admirable portico, and graceful side porch. It was the first Houston home equipped with central heating, and Mamie Donoghue proclaimed it to be "warm as toast" in the mornings, an assertion contested by family members. (Both courtesy of Jeff and Suzanne Brown.)

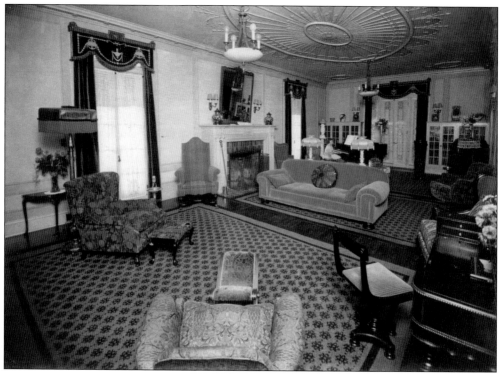

Thomas J. Donoghue, "T. J.," (1869–1945) was born in the oil patch in Titusville, Pennsylvania. His father was a refiner who refused to sell to Rockefeller and Standard Oil. It was a pyrrhic victory, and young T. J. was forced to sell newspapers to help support the family. At 13, he worked for Western Union Telegraph and then joined Standard Oil for 18 years, learning all aspects of the oil business. His opportunity came when J. S. Cullinan invited him to Corsicana and then Beaumont. In 1896, T. J. married Mamie Sullivan. Mamie was tough-minded; grandson Jeff Brown related that Mamie was determined not to fail and put the steel into T. J. to stay in Beaumont despite the deplorable, and often dangerous, conditions. She was convinced that their future lay in Texas. (Both courtesy of Jeff and Suzanne Brown.)

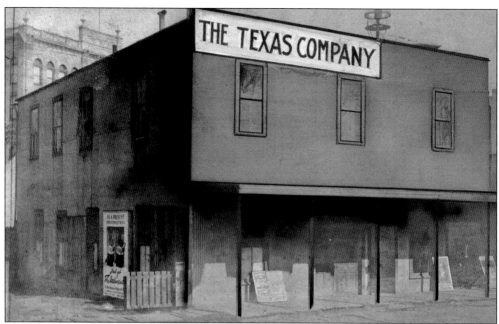

Edwin Rice Brown, T. J.'s son-in-law, recalled him as a "young and personable Irish Catholic bookkeeper with personal knowledge of the infant oil business" whose business acumen and organizational skills were essential to the Texas Company's success. The Donoghues paid their dues in Beaumont. At one point, Mamie put baby Francis in the fireplace, shielding him from a gunfight in the street. But T. J. was one of the first to see that the oil business, despite its wild speculative beginnings, could be profitably operated through application of sound economic principles. Perhaps this devotion to regularity, coupled with his childhood memories of uncertainty and poverty, kept T. J. in the Texas Company after Cullinan, Autry, and Will Hogg resigned in a management dispute. If there were grudges, they did not last. T. J. was a pallbearer at Autry's funeral. (Both courtesy of Jeff and Suzanne Brown.)

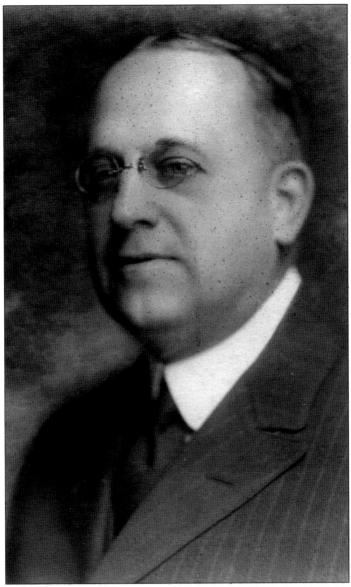

Early Texaco gas station signs flashed a green "T" to honor the Irish roots of T. J. Donoghue, company vice president from 1902 to 1939 and chief executive in Texas after headquarters moved to New York. T. J. was twice offered the company presidency, but Mamie refused to be uprooted. A political conservative, he declined to participate in Social Security but possessed a sincere public spirit and deep religious faith. His commitments included the Houston Chamber of Commerce, Community Chest, Round Table of the National Conference of Christians and Jews, Housing Authority Board, YMCA Newsboys Camp fund committee, Holy Rosary Church, Knights of Columbus, Serra Club, and Catholic Club of New York. After T. J.'s death, the National Conference of Christians and Jews called him "an ardent and able champion of causes and institutions that helped to advance that which is good and beautiful in life." A *Houston Post* editorial recalled his Horatio Alger–like beginnings: "Probably one reason so many people remember the vice president is that the vice president remembered the paper boy." (Both courtesy of Jeff and Suzanne Brown.)

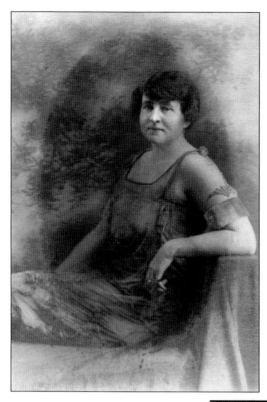

Mary Evangelist Sullivan Donoghue, "Mamie," (1875–1963) at 5 feet tall was a formidable woman. Her family asserted that "she could make the world spin the other way 'round if she wanted." Her ambition and drive contributed to T. J.'s success, but she was rigid and controlling. Mamie's adult sons checked in every evening for a cocktail. In old age, she frequently fired her entire household staff, touching off a predictable family uproar before relenting and rehiring everyone. During a house call, her doctor noticed that Mamie's symptoms echoed those expressed on the soap opera she was watching. Son-in-law Ed Brown wrote, "She was admired and respected, but not loved, as she longed for. None of her children married to suit her but all tried." At her death, Ed felt he had lost a "great adversary." (Both courtesy of Jeff and Suzanne Brown.)

The Donoghue children were Francis Joseph, Gerald Thomas, and Mary Catherine, who was four years old when her family moved into Courtlandt Place. Gerald ("Jerry") was an accomplished horseman who rode in Hermann Park and may have kept a horse on Courtlandt Place. Jerry introduced Mary Catherine to her husband, Ed Brown. T. J. gifted Mary Catherine with a Buick Roadster convertible in 1929 when she was 16, and the young debutante gained a hoydenish reputation tearing around in defiance of her mother's rules. T. J. doted on his daughter, but she and Mamie clashed. Mamie always challenged Mary Catherine's ideas, and the complicated relationship probably contributed to Mary Catherine's rebelliousness and her alcoholism later in life. Mary Catherine ultimately acknowledged her alcoholism and spent later years as a counselor in Alcoholics Anonymous. (Both courtesy of Jeff and Suzanne Brown.)

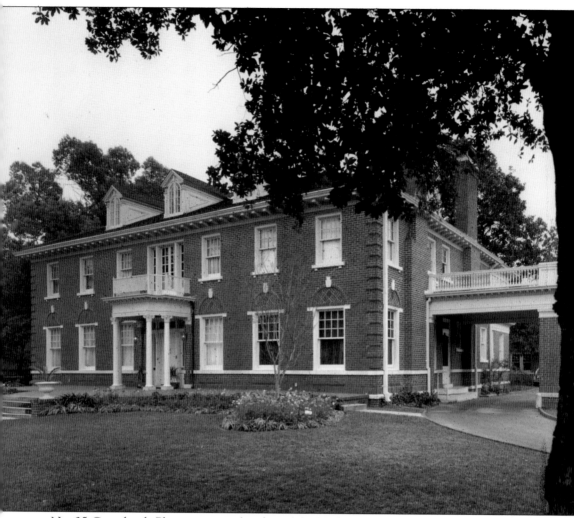

No. 25 Courtlandt Place was completed 1916 for Underwood and Clara Nazro. Underwood Nazro (1875–1935) was a founding investor of the Gulf Oil companies, later vice president and chief executive officer in Houston. The Georgian Revival house marked a stylistic departure for architects Sanguinet and Staats, whose previous homes on the boulevard reflected Tudor and Mediterranean influences. The success of the Donoghue house by outsiders Warren and Wetmore may have inspired this similar, if somewhat less ornate, residence. Underwood was born in Kentucky and followed the oil scent to Texas where he married Clara Wheeler (1882–1942), daughter of a prominent Beaumont family. With his wife's money, Underwood invested in the J. M. Guffey Petroleum Company, a consortium of drillers of the primary Spindletop gusher, R. B. Mellon of Pittsburgh, and other Eastern investors. Within a year, the investors formed Gulf Refining Company to refine and sell Guffey oil, and the two companies merged, with William Mellon as head of operations. By 1907, Guffey and many other smaller producers had disappeared into the Gulf Oil companies. (Courtesy of E. A. Kopinitz.)

In 1929, Jesse H. Jones, real estate and banking magnate, built a structure "of strikingly modern design" to house his powerful National Bank of Commerce. The Gulf Building rose to 37 floors at the corner of Main and Rusk Streets and was the tallest building in Houston until 1963. Its observation deck boasted an aeronautical beacon and long-range telescope, which reached Galveston on a clear day. Besides Jones's bank, its tenants were Gulf Oil and Sakowitz Brothers Department Store. Bobby Sakowitz recalled that Jones offered the building's naming rights to his grandfather, Tobias, for $25,000. Tobias Sakowitz demurred, saying he needed the money "for inventory." Underwood and Jones personally negotiated Gulf Oil's lease and, presumably, the naming rights. The company's move from offices across Rusk Street into the Gulf Building was the largest relocation of its kind south and west of St. Louis to that date and necessitated street closures nightly for 10 days. In 1965, an enormous rotating sign on the observation deck, dubbed the "Gulf Lollipop," became a Houston landmark until dismantled in 1974. (Courtesy of Houston Endowment.)

Underwood Nazro's career in the oil business yielded impressive accolades and substantial wealth. The Nazros were among 10 Courtlandt Place families who belonged to the fledgling Houston Golf Club, a group later reorganized into the Houston Country Club. Golf was a passion for Clara, who competed competitively as early as 1917. They had two children, Wheeler and Joanna. Underwood and Clara eventually moved to the newer suburb of River Oaks, where Underwood died at age 59. Clara died of cirrhosis of the liver seven years later. On May 8, 1935, the board of directors of the San Jacinto National Bank passed a resolution stating in part: "Mr. Nazro came from the ranks. He began his career as a day laborer, but he was built of the elements that meant success. His great heart, his splendid mind, his indefatigable energy, would have carried him forward in any endeavor of life and in any pathway which he chose to pursue. His resulting success is an example to be emulated by every American boy . . ." (Courtesy of Houston Endowment.)

Five

BUSINESS AND
PROFESSIONAL MEN

The early 20th century brought Houston unprecedented growth. The population nearly doubled between 1900 and 1910, and the number of factories and wage earners was the highest in the Southwest. Seventeen railroad lines expedited 200 departures daily, and the financial center included six national banks with assets of $45 million. The city's cultural stock rose with the establishment of Rice Institute. But a crucial element of the new prosperity was the Houston Ship Channel, a dream of Houstonians almost since the city began.

Since the 1850s, Houston merchants had chafed beneath Galveston tariffs and sought a deepwater home port and direct channel to the sea. In 1874, shipping magnate Charles Morgan dredged the first ocean-vessel channel in Buffalo Bayou from the bay to Clinton, south of Houston. Railroad magnate John T. Brady, father-in-law of Wanroy Garrow, envisioning an extension of Morgan's deepwater channel, bought 4,000 acres along the bayou but died before his plan could be executed.

In 1890, the U.S. government purchased Morgan's channel, and dredging faltered, even as ocean ships increased in width and draft. By 1909, the channel languished at an inadequate 18.5 feet, frustrating attempts to lure maritime commerce into Houston's fledgling port. In 1914, Mayor Horace Rice offered to pay one-half of the cost of dredging to 25 feet. Congress accepted, establishing the "Houston Plan" as a precedent for all future federal public works projects. Harris County approved a bond issue of $1,250,000, but local restraint jeopardized the venture. Jesse Jones and bankers W. T. Carter and Edwin Neville pressured banks to purchase the bonds. All sold in less than 24 hours.

Courtlandt Place business and professional men flourished in this climate of opportunity. Charles Neuhaus invested in rice mills and real estate and was one of Houston's first investment bankers. Alexander Cleveland owned a prosperous wholesale grocery supply company and served as a Rice Institute trustee. Murray Jones was a politically connected attorney and judge. And Donald Hall was a builder who thought big and built big and left the Warwick Hotel, the Beaconsfield, and other Houston landmarks.

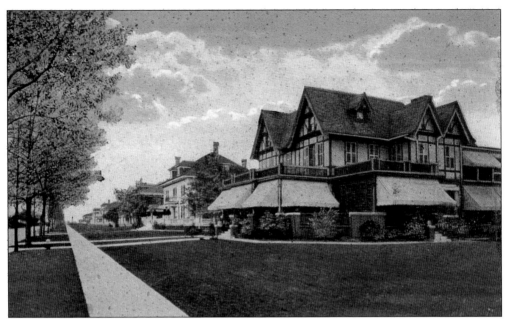

The Tudor Revival home at 4 Courtlandt Place was designed by Sanguinet and Staats and completed in 1910 for Sterling Myer, the chief developer of Courtlandt Place. Two subsequent owners grew old in the house and were unaware that it was deteriorating. New owners who appreciate the home's charm and irreplaceable history have undertaken substantial renovations and updates to bring the house into the 21st century. Armed with vintage photographs, they have restored missing original features, including the distinctive railing along the roofline. Another family has discovered the joys of living in a historic house in Courtlandt Place, and part of Houston's heritage has been preserved for years to come. (Above courtesy of Bonner Sewell Ball; below photograph by Benjamin Hill.)

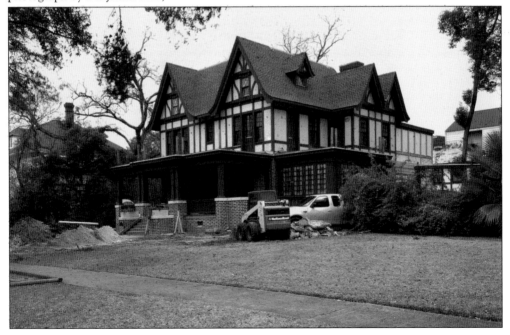

Attorney and real estate investor Sterling Myer (1872–1938) was born in Plantersville, Texas, and received his law degree from the University of Texas. His law firm, Campbell and Myer, received a $25 monthly retainer for managing Courtlandt Place business until 1912. He and his wife, Alice, had two children: a son, Sterling Jr., and a daughter, Jane. A very public person, Sterling accrued a long list of civic contributions. He was a major benefactor and member of the board of the Star of Hope mission and a long-serving vestryman for Christ Church. Both the *Houston Post* and *Houston Chronicle* reported his death in front-page stories. The *Houston Post* wrote, "As a man, he was admired and respected by thousands. A fine conversationalist, he moved in brilliant social circles, and lived in an atmosphere of intellectual, spiritual, and cultural accomplishment. The city which respected and admired him will miss his wise counsel and unselfish devotion to its welfare." (Courtesy of Sterling Myer III.)

Deane, HOUSTON, TEXAS.

Alice Bentley Myer (1873–1968), whose mother was a well-known milliner in Houston, married Sterling in Atlantic City, New Jersey, in 1897. Both Alice and her husband were progressive thinkers. Sterling was an early proponent of the innovative Private Place concept in Houston, and although Courtlandt Place was his single large real estate venture, it proved to be one of the city's most enduring neighborhoods. Alice shared Sterling's progressive attitude and served as treasurer of the Equal Suffragists of Texas. One may speculate that she and Frankie Carter Randolph would have had much in common. Alice and Sterling were charter members of the Houston Country Club and were also intrepid travelers. They were photographed on camels at the pyramids, and cruised to within sight of the North Pole, where, according to a newspaper article, Sterling reported "having come under the spell of the Northern Lights." Sterling and Alice lived on Courtlandt Place only a few years before moving to Yoakum Street. After Sterling's death, Alice lived at the Warwick Hotel. (Courtesy of Sterling Myer III.)

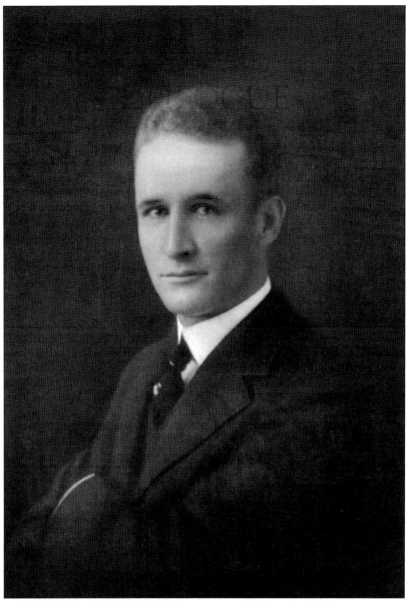

James Donald Hall, "Don," (1885–1964), a later owner of 4 Courtlandt Place, grew up on a ranch near Cotulla, Texas. His father, Dick Hall, was state land commissioner and ran for governor against James Hogg. Young Don was in thrall of his dashing uncle Lee Hall, a captain of the Texas Rangers famous for his derring-do. Another who admired Lee was the Halls' semi-permanent houseguest, Will Porter, who gained literary fame as O. Henry. Porter based his tales of the Wild West on Lee Hall's adventures and his own days on Dick Hall's ranch. Not surprisingly, Don was a big thinker who wanted to make his mark. Trained as a mechanical engineer at Cornell and the University of Texas, Don became a builder and put his imprimatur on the Houston skyline. He built the Cotton Exchange, Museum of Fine Arts, YMCA, Warwick Hotel, *Post-Dispatch* newspaper, Houston National Bank, Gulf Publishing, and Junior League buildings, to name but a few. Don was good looking, smart, funny, and enjoyed the company of women. (Courtesy of Bonner Sewell Ball.)

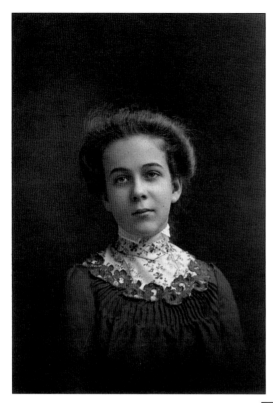

Virginia Dorrance Hall (1888–1971) was the daughter of John Dorrance of 9 Courtlandt Place. Virginia was beautiful, devoutly Catholic, accomplished socially and intellectually, and a "lady's lady," according to granddaughters Bonner Sewell Ball and Virginia Sewell. She married the charismatic Don Hall in 1915, and the couple moved to Dallas for a short time. John Dorrance purchased 4 Courtlandt Place, across the boulevard from his own home, for the young couple when they returned to Houston, probably in 1919. Virginia lived in No. 4 until its sale in 1968. (Both courtesy of Bonner Sewell Ball.)

Don Hall was a success in his business, and he and Virginia stepped easily into the Courtlandt Place lifestyle with servants, glittering social functions, and summers on Maryland's Eastern Shore and in the mountains of North Carolina. The Halls had three children, John, Betty, and Don Jr., whose difficult birth resulted in mild retardation. All three children were accomplished horsemen, even Don Jr., pictured on his paint pony. Along with other residents of Courtlandt Place like Deke and Frankie Randolph and Alice-Baker Jones, the Halls enjoyed the polo matches at the Houston Polo Club near present-day Memorial Park. (Both courtesy of Bonner Sewell Ball.)

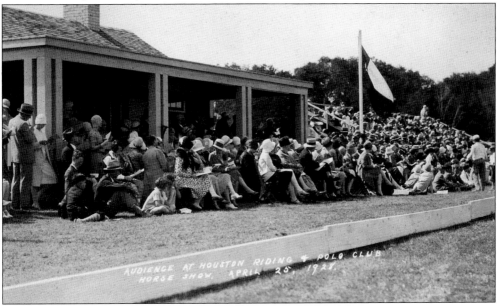

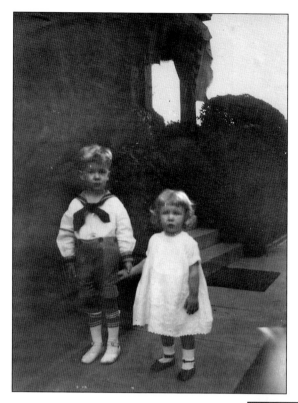

Don often accepted payments for his work in stock certificates. When the Great Depression hit, he was ruined overnight. He moved his family to Glenwood, Colorado, in a vain attempt to recoup his fortune in a silver mine owned by John Dorrance. In a poignant letter, young Betty Hall writes to Don's sister Mab, "I wish you could see how we dress up here. Daddy wears a union suit, army shoes, putties, and a big sheepskin coat. . . . Daddy had a hole in his glove and one of his fingers got frostbitten. It is all black." One of Don's associates wrote to him, "your fortunes and misfortunes have not changed my opinion. To me, you are still the swellest guy in the world." The Halls returned to Houston, no richer, on the eve of World War II. (Both courtesy of Bonner Sewell Ball.)

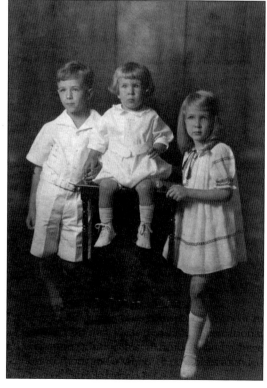

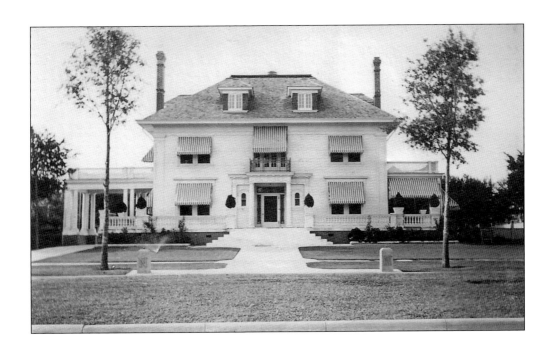

No. 6 Courtlandt Place was completed in 1909 by Sanguinet and Staats for Charles and Emilie Neuhaus. The white wedding cake of a house exhibits Beaux Arts eclecticism and was the first home built on the boulevard. Its outbuildings included a carriage house, large stable, small stable, hen house, and servants' quarters. In the service yard, a fuel pump surmounted an underground gasoline tank, which was filled by regular deliveries from a Humble Oil truck. The Neuhaus family was proud of their German heritage and furnished their home with furniture and treasures brought from Germany. (Both courtesy of the Neuhaus family.)

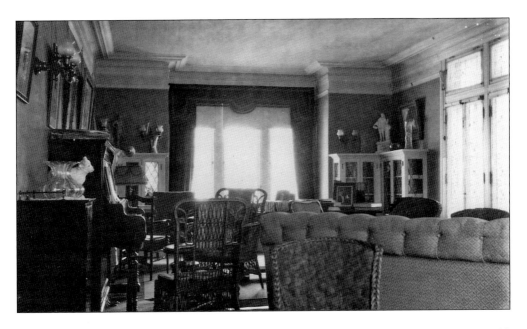

Franz Charles Ludwig Neuhaus, "Charley," (1857–1930) was born in Hackberry, Texas, to an established and prosperous mercantile and farming family. Charley's parents, siblings, and collateral family preceded him to Houston. Charley was a seasoned and successful businessman when he moved to Houston in 1906. A director of the Texas Rice Mill Company and Union National Bank, he segued easily into the city's business milieu. Perhaps as a holdover from his self-sufficient country roots, he made few civic and philanthropic commitments, concentrating instead on business and social ties. He helped to form the Houston Golf Club and became a charter member of the Houston Country Club. He was a primary investor and trustee in the Courtlandt Improvement Company, a venture grandson Phillip Neuhaus speculated may have been attractive as a continuation of previous successful land transactions conducted in Hackberry. A niece, Lillie Neuhaus, married Bill Carter and lived at 18 Courtlandt Place. (Courtesy of the Neuhaus family.)

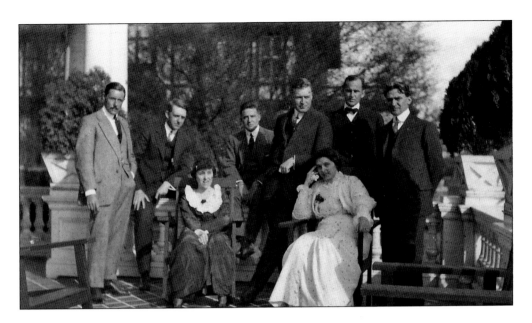

Above, Neuhaus daughters Erna (seated left) and Ilse (right) are pictured with brother Hugo (far left). Hugo graduated from Rensselaer Polytechnic Institute and worked as a civil engineer in Arizona before returning to Houston. Nicknamed "Baron," he married Katherine Rice, a niece of William Marsh Rice, and had five children, including Hugo Jr., nationally recognized architect and Houston civic benefactor. In 1907 at age 25, Hugo founded Neuhaus and Company, the first brokerage and investment banking house in Texas. Charley was an executive in the firm. In 1908, the Courtlandt Improvement Company retained Hugo as sole agent for the sale of Courtlandt Place lots. (Above courtesy of the Neuhaus family; below photograph by Benjamin Hill, courtesy of the Courtlandt Place Civic Association.)

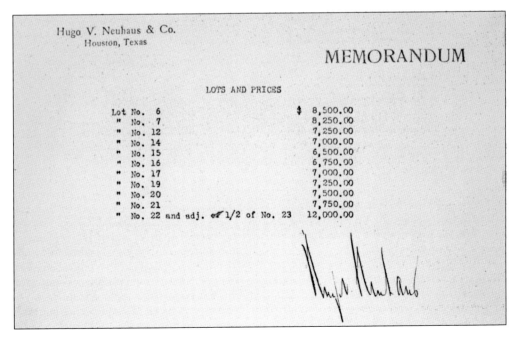

Hugo V. Neuhaus & Co.
Houston, Texas

MEMORANDUM

LOTS AND PRICES

Lot No. 6	$ 8,500.00
" No. 7	8,250.00
" No. 12	7,250.00
" No. 14	7,000.00
" No. 15	6,500.00
" No. 16	6,750.00
" No. 17	7,000.00
" No. 19	7,250.00
" No. 20	7,500.00
" No. 21	7,750.00
" No. 22 and adj. of 1/2 of No. 23	12,000.00

Emilie Joanna Boettcher Neuhaus, "Millie," (1861–1943) shared her husband's central Texas German roots and was educated at boarding school in Germany. She and Charley married in 1881. Millie always hired cooks from Weimar or Fredericksburg, Texas, both German-American strongholds. The family also employed a full-time maid and houseman. The Neuhauses raised chickens and kept horses, a milk cow, and a goat, which occasionally grazed on the esplanade. Every summer, Millie replaced her heavy German furniture with light and airy wicker. World War I was agonizing for her. On the early April morning in 1917 when Jimmie Autry fired his pistol to announce the declaration of war with Germany, the residents congregated on the boulevard in their nightclothes. Millie turned to Virginia Cleveland and asked tearfully if they would still be friends. (Both courtesy of the Neuhaus family.)

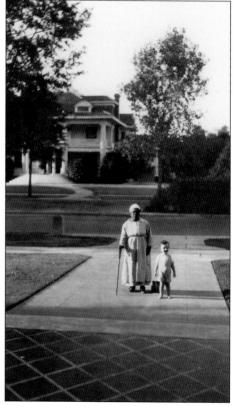

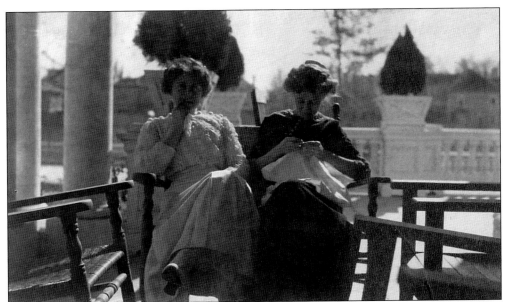

Ilse (left) and Erna (right) are pictured on the front porch of the Neuhaus home. Erna belonged to the Texas Women's Golf Association and played at the Houston Country Club. She married Morton C. King, a captain in the U.S. Army in World War I, in 1919. Later that year, shortly before their son Morton King Jr. was born, King traveled to San Antonio, where he died tragically of a gunshot wound. Erna continued to live at 6 Courtlandt Place until the house was sold in 1945. Morton King Jr. and a Hall daughter from 4 Courtlandt Place, Betty Hall Sewell, were romantically linked for a time as young persons. Morton King Jr. did not marry until middle-age. (Above courtesy of Sara H. Stadeager-Andersen; below courtesy of the Neuhaus family.)

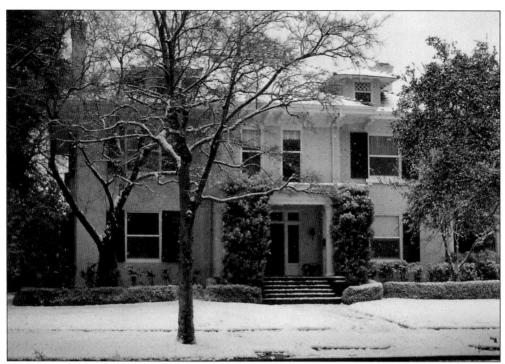

No. 8 Courtlandt Place, designed by Sanguinet and Staats with A. E. Barnes, was completed in 1911 for Alexander S. Cleveland at a reported cost of $20,000. It was the third home built on Courtlandt Place and was occupied by the extended Cleveland family for more than 60 years. Its eclectic facade is predominantly Colonial Revival with Mediterranean embellishments, yet it also exhibits strong Prairie School features, particularly in the overhanging eaves and one-over-one plate-glass windows. In 1929, John Staub paneled the living room in birch, enhanced the fireplace with marble, installed a powder room on the first floor, and screened the east portico. Except for periodic kitchen and bath renovations, the house remains substantially unaltered. (Above courtesy of Virginia Kirkland Innis; below courtesy of the Neuhaus family.)

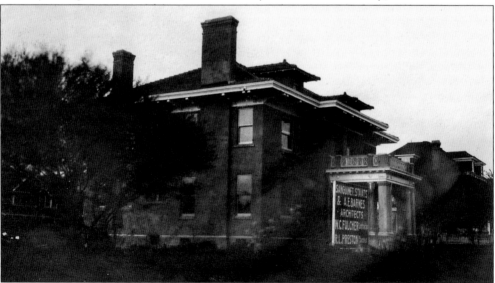

Alexander Sessums Cleveland, "Sess," (1871–1954) attended the University of the South and Yale University. His father, W. D. Cleveland, had the largest wholesale grocery business in Houston and a cotton factorage. When the elder Cleveland experienced financial losses, Sess and his brother paid the debts in full. Sess was a talented businessman whose management benefited the family companies, and he shrewdly sold the cotton factorage prior to the agricultural crash in the 1920s. He was heavily engaged in civic affairs, particularly the school board, the chamber of commerce, and the Houston Chapter of the American Red Cross. He was a trustee, later trustee emeritus, of Rice Institute. After his death, Rice Institute trustees wrote in tribute, "Steadfast to purpose and principle, he believed in what he stood for and stood for what he believed. . . . Of youthful and buoyant mien throughout his years, and with ready wit, good humor, and optimism . . . We shall always revere his memory, as men revere the memory of another man well loved for himself and for a life well lived." (Courtesy of Metropolitan Research Center, Houston Public Library.)

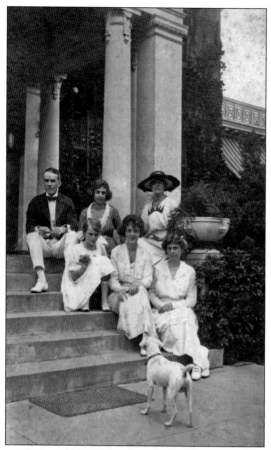

Sess and Virginia Cunningham (1875–1965) had four daughters: Lois, Nora, Tina, and Virginia, who died at age 22 months. According to granddaughter Virginia Kirkland Innis, theirs was a "happy house" and a frequent gathering place for young people's parties as well as the many social, business, and philanthropic functions given by the Clevelands. Sess was friendly and personable but controlling and prone to bouts of depression. Sess and Virginia maintained strict Victorian standards and a well-run house. Barbara Kirkland Chiles remembers the cook as "mean" but has fond memories of her "divine" cuisine. Dinners and Sunday luncheon were served formally with the butler standing ready behind a screen in the dining room. By June 1 every year, the family decamped to Virginia or Maine. (Above courtesy of Barbara Chiles; below courtesy of Virginia Kirkland Innis.)

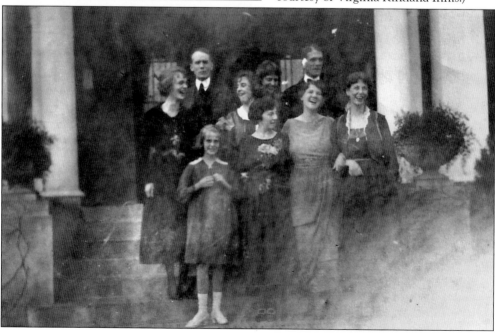

Virginia and Sess Cleveland married in 1896. Virginia was from Savannah, Georgia. Virginia Ennis and Barbara Chiles remember their grandmother, at right with her daughter Lois Kirkland, as "a genteel lady," very much concerned for her husband's welfare. The Clevelands, at left in the photograph above, are pictured at their 50th wedding anniversary celebration. The very social Cleveland daughters married well. Lois married William Kirkland, a great-grandson of Benjamin Shepherd, and later built a home next to her parents. Tina married Dudley C. Sharp of Houston, son of the partner of Howard Hughes Sr. *Houston: The Unknown City 1836–1946* records that young Howard Hughes, bouquet in hand, attended the dance given by the Clevelands for Tina's eighth birthday. Nora married C. P. Greenough of New York City. (Both courtesy of Virginia Kirkland Innis.)

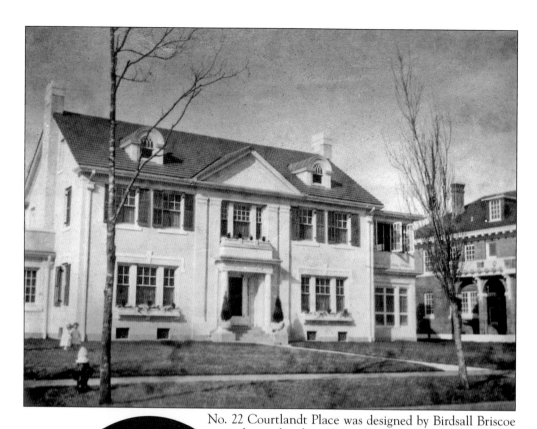

No. 22 Courtlandt Place was designed by Birdsall Briscoe and completed in 1917. The Georgian Revival home's stuccoed hollow-tile construction, rarely found in a private residence, is considered highly energy efficient. It was built for Murray Brashear Jones (1886–1963) and Alice Baker Jones (1887–1978) by Capt. James Addison Baker, Mrs. Jones's father, the same year that baby Alice-Baker Jones was born. Murray Jones's grandfather, Isaac Brashear, was a Houston pioneer who arrived in the city in 1839. Brashear's farm was eventually sold to the developers of the Houston Heights. Murray attended the University of Texas and Princeton University, where one of his professors was Woodrow Wilson. Murray returned to the University of Texas, studied law, was admitted to the bar in 1910, and practiced for 50 years. (Above courtesy of Woodallen Photography–Houston; below courtesy of Sara H. Stadeager-Andersen.)

Capt. James Baker and his daughter, Alice Baker Jones, are pictured with toddlers Alice-Baker Jones and Effie Hunt, cousins and next-door neighbors. Captain Baker holds Effie (left) and Alice-Baker (right). On the same day in 1915, Baker purchased and transferred ownership of two lots in Courtlandt Place. No. 22 was presented to the Joneses, and No. 24 was sold to Sarah Brashear Jones, Murray's mother. Baker was an attorney in the firm founded by his father, at that time named Baker, Botts, and Baker. A legal and political powerhouse, he represented William Marsh Rice and, after Rice's mysterious death, his estate. Baker unraveled the complexities and conflicting claims surrounding Rice's will and saved the extremely lucrative assets for Rice Institute. (Both courtesy of Sara H. Stadeager-Andersen.)

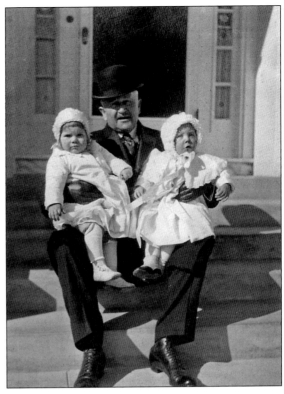

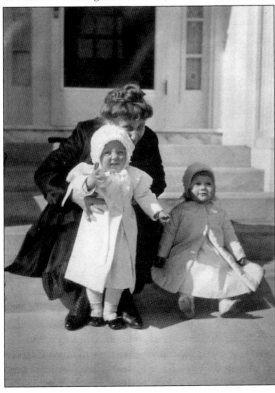

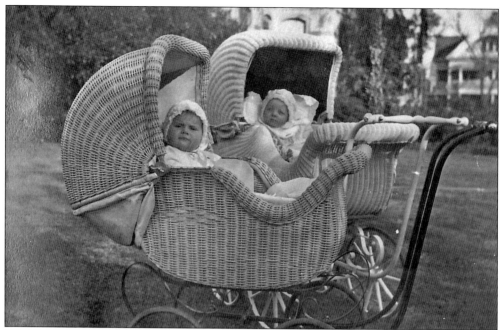

Effie Hunt and Alice-Baker Jones grew up together, attended the same Houston schools, belonged to the same clubs, and graduated from the Kinkaid School. They are pictured in their prams and then at the Kinkaid School graduation. Both are on the back row, Alice-Baker third from left and Effie second from right. They attended Miss Spence's School in New York. After graduation from Spence, Alice-Baker traveled extensively in Europe. She returned to Houston to make her debut and was queen to King Nottoc IX of the No-tsu-oh Carnival. Money and social position could not create a joyful union for Alice-Baker's parents. The adult Effie Hunt Heald, interviewed in the 1980s, revealed that Alice and Murray Jones were deeply unhappy. They divorced in the 1920s, and Alice remained in No. 22 until 1946. (Both courtesy of Sara H. Stadeager-Andersen.)

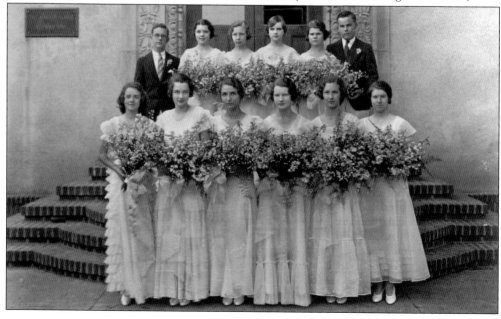

Six

ENTR'ACTE

In the first years between the wars, Houstonians enjoyed peace and the prosperity that rode its coattails. But peace carried change as well. As the oil industry took hold, Houston moved from a region-based economy to one with a national and ultimately international focus. The city's population swelled to nearly 300,000. Overwhelmed by sheer numbers, the Old Guard's grip on commerce and society began to loosen. Traditional social clubs were supplanted by the increasing popularity of country clubs.

New houses and new families arrived on Courtlandt Place. The boulevard remained an elite address, but other significant Private Place neighborhoods developed, fueled by the new economy. In 1925, the River Oaks Corporation bet on Houston's growing passion for golf to bring them success in their new country club development 8 miles west of downtown.

In the enlightened postwar atmosphere, women became a more public force. The 19th Amendment to the U.S. Constitution was ratified in 1920, and Frankie Carter Randolph helped organize the Houston Chapter of the League of Women Voters. By 1925, the Blue Bird Circle, the Houston Zoo, the Houston Garden Club, the Museum of Fine Arts, and the Junior League of Houston had been founded by women. Frankie Randolph and Nora Cleveland were two of 12 women who founded the Junior League. Enlisting 30 charter members, they opened a luncheon club in the basement of the W. T. Carter Lumber Company to make project money. Virginia Cleveland and Monie Parker helped found the Museum of Fine Arts.

In the last years between the wars, the prosperity of peace faltered beneath the weight of the Great Depression. A concerted effort spearheaded by Jesse Jones guaranteed that no Houston bank went under. Even so, only one home was built in Courtlandt Place after 1930; another would not appear until the 1970s. The resiliency exhibited by the neighborhood after the first war evaporated during the second. When peace and prosperity came around again, Courtlandt Place was ignored. Houston's elite, even many of the Old Guard, had moved west to River Oaks and the piney tracts beyond Memorial Park.

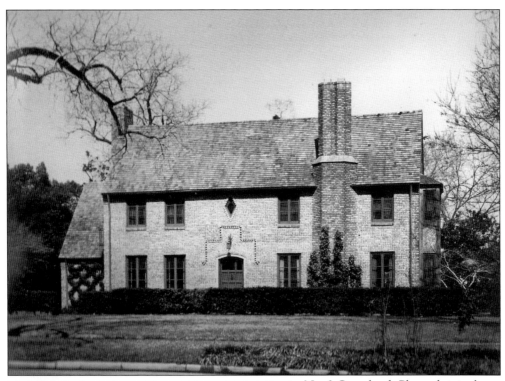

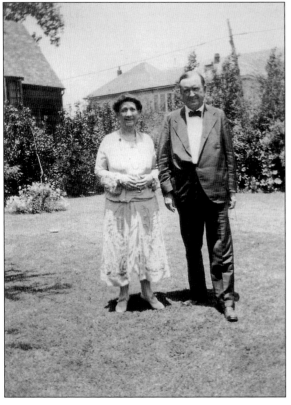

No. 2 Courtlandt Place, the single John Staub–designed house on the boulevard, was completed in 1926 for Judge John and Monie Parker. Staub developed his style working for New York architect Harrie T. Lindeberg and embraced Lindeberg's abhorrence of ostentation. The Parkers' home is particularly restrained, relying on ornamental brick detail to enrich its simple lines and offers a more approachable scale than some of its neighbors. The couple requested a house to accommodate two persons, but they were seldom without extended family. The gardens were renowned and much more extensive prior to the intrusion of Spur 517. Carroll Masterson, chatelaine of Rienzi, a Staub-designed home later acquired by the Museum of Fine Arts Houston, named one of her fabled gardens "Mrs. Parker's Garden" in homage to the Parker gardens. (Above courtesy of Woodallen Photography–Houston; below courtesy of Joan O'Leary.)

John Wilson Parker, "Judge," (1861–1930) built a flourishing law practice in the railroad town of Taylor, Texas. After the railroad relocated, Judge moved to Houston. He was twice elected to state office, without campaigning, and refused to accept on both occasions, stating that he could better serve the community as a private citizen. Judge did serve several appointments as a special justice of the Texas Supreme Court. Upon his death, the Harris County Bar Association called him "one of the leading lawyers of the state." Bessie Coelhite Parker, "Monie," (1864–1948) grew up in Georgia on a cotton plantation. The family was impoverished by the Civil War, and Monie came to Texas to earn her living as a piano teacher in Taylor. (Photographs by Benjamin Hill; above courtesy of J. Parker Fauntleroy Jr.; below courtesy of Betsy Parker Fauntleroy Glasgow.)

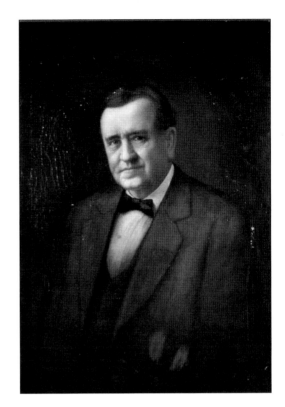

Judge and Monie Parker had two daughters, Bess and Mary. The girls were grown when the Parkers moved to Courtlandt Place. Mary married, lived in Georgetown, Texas, and had five children. Bess, pictured as an adult, stayed in Houston, married DeWitt C. Dunn and also had five children. Judge and Monie's grandchildren feared Judge's lightning temper but were equally sure of his big heart. Bess Dunn and her family moved to Courtlandt Place to live with Monie after Judge's death in 1930, and all or some of Bess's children and grandchildren were often in residence until Monie and Bess moved after World War II. (Both courtesy of Joan O'Leary.)

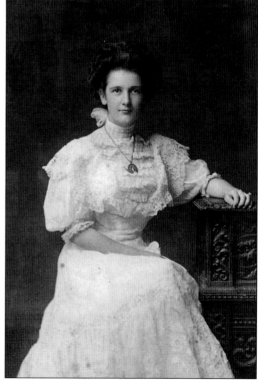

Fleeing the aftermath of war, poverty, and societal disruption in her native Georgia, Monie struck out for Texas with her brother and sisters to start a new life. According to great-granddaughter Joan O'Leary, Monie was a small "bird-like" woman, very warm and welcoming, a legendary hostess who kept "a good table" but never cooked. Her passion was gardening and the arts, and she was among the first directors of the Museum of Fine Arts. All grandchildren and great-grandchildren were required to memorize and recite poetry, particularly Tennyson. O'Leary remembers "the most wonderful" morning walks with Monie, reciting poetry and being encouraged to observe the beauty around her. She recalls "running barefoot, free and wild" on Courtlandt Place with the Carter and Taylor grandchildren and learning to play cards in Jessie Taylor's basement. (Both courtesy of Joan O'Leary.)

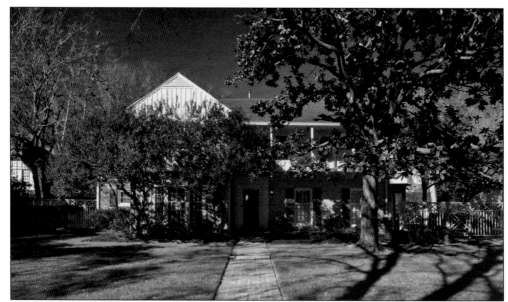

No. 10 Courtlandt Place was completed by S. I. Morris in 1937 for Lois and William Kirkland. Constructed in the depth of the Great Depression with war brewing again in Europe, the late Colonial Revival house marked the end of an era on Courtlandt Place. The extravagant flourishes that graced older and larger boulevard houses were passé; in tune with the somber times, the Kirkland house presented a more restrained countenance. It was also a somber time for the Kirklands, who had experienced devastating financial reversal and lost their previous home. Lois Kirkland's uncle, W. D. Cleveland Jr., owned the lot on Courtlandt Place next to the home of his brother and Lois's father, Sess Cleveland. W. D. Cleveland gave the Kirklands his lot for their replacement house. (Above photograph by Benjamin Hill; below courtesy of Virginia Kirkland Innis.)

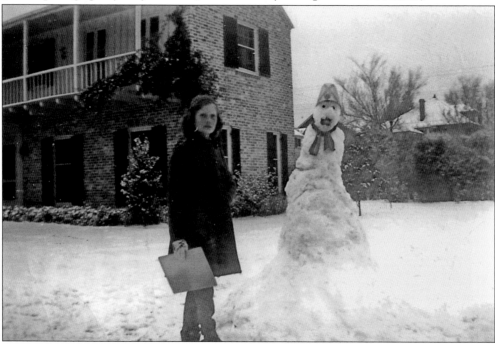

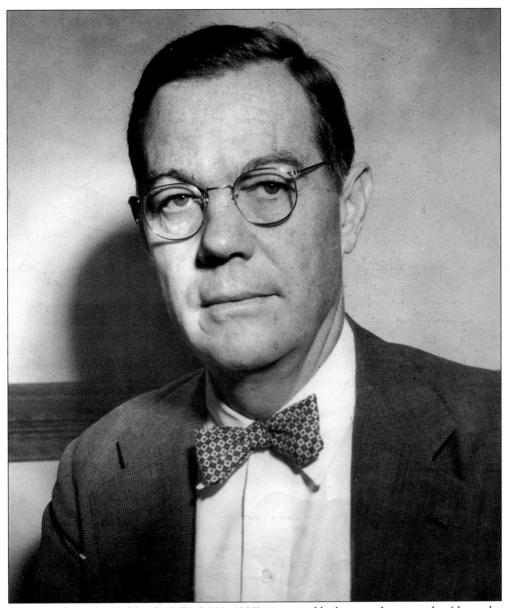

William Alexander Kirkland, "Bill," (1898–1988) was raised by his grandparents, the Alexander Roots, in their downtown mansion. One of only three boys who attended the Misses Waldo's School, Bill was soon removed by his grandfather to Professor Welch's Houston Academy to study Greek and Latin, prerequisites for entrance to the Ivy League. He ultimately attended Andover and Yale, although his studies were interrupted by service in World War I. President and later chairman of First National Bank, Bill wrote a history of the bank, *Old Bank—New Bank*. He included a riveting firsthand account of the two all-night meetings held in Jesse Jones's office during the bank panic of October 1931. Jones summoned Houston's bankers and leading business and professional men to hash out the plan that prevented Houston's banks from failing. Bill later worked for Jones in the Reconstruction Finance Corporation in Washington, D.C. In Houston, he served on the school board and was instrumental in bringing the battleship *Texas* to dock at the San Jacinto Monument. (Courtesy of Metropolitan Research Center, Houston Public Library.)

Lois Cleveland Kirkland (1898–1986) (left) was a daughter of the Sess Clevelands. The families are pictured at the Clevelands' 50th wedding anniversary. Lois and Bill had two daughters, Virginia and Barbara, and were popular in Houston society. Virginia Kirkland Innis remembers Bill as "a tall, handsome man; everybody loved him." She recalls Lois as "a somewhat difficult personality" and that Bill usually supported his daughters in family disputes. Close proximity to the Clevelands next door may have been hard for Bill, as Sess remained very controlling of Lois, but Innis cannot recall any instance of her father showing irritation. As a child, Innis contracted polio and spent many months without her mother in the sanitarium at Warm Springs, Georgia. President Roosevelt was often there, and she remembers attending Thanksgiving dinner with the president in 1933. (Both courtesy of Virginia Kirkland Innis.)

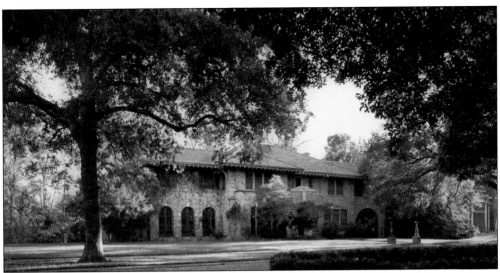

No. 15 Courtlandt Place was completed in 1925 by architect Carlos B. Schoeppl for two sisters, Caroline Bryan Chapman, "Caro," (1859–1933) and Johnelle Bryan (c. 1861–1935), daughters of a Texas pioneer family. Schoeppl was famous for his Spanish and Mediterranean houses in Texas and, after 1926, mansions in Florida. His design for the sisters incorporated Ludowici tile for the roof and Acme brick instead of painted stucco, an unorthodox choice. The Renaissance fireplace mantel was possibly acquired by the sisters in Italy. Caro and Johnelle frequently held concerts in their home and had an Aeolian organ installed in the reception hall. Oil wildcatter Joseph F. Bashara (1888–1970) purchased the house in 1935. He and his wife, Wadeha Merriam Unice (1897–1981), continued the tradition of hosting musical entertainments. (Above courtesy of Woodallen Photography–Houston; below photograph by Benjamin Hill, courtesy of Michael O'Connor.)

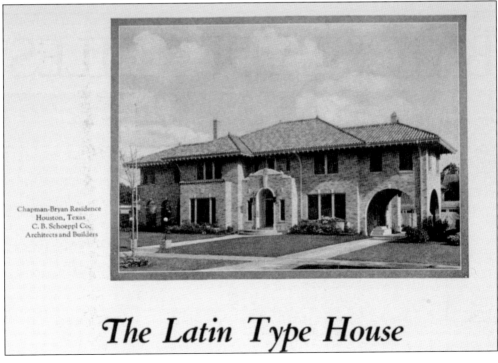

Chapman-Bryan Residence
Houston, Texas
C. B. Schoeppl Co.
Architects and Builders

The Latin Type House

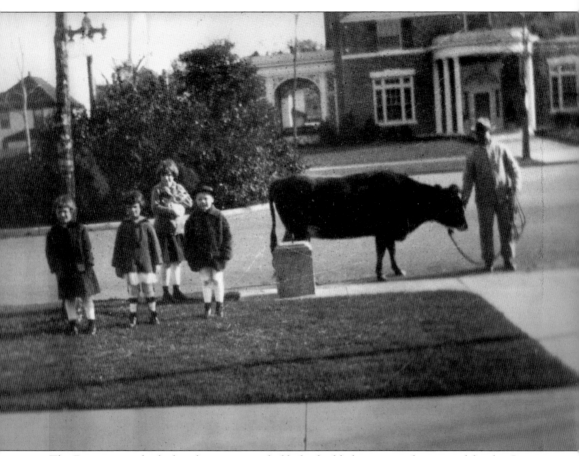

The Bryan sisters built their home on one-half of a double lot previously reserved for the Carter family's milk cow. The expansive grounds imparted the look and feel of an estate, and the house was commended for its fine gardens and gazebo. The source of the sisters' wealth is unclear. Caro, a widow, may have inherited wealth from her husband, or the sisters may have profited from their late father's real estate holdings, or both. Their father was Houston dentist and real estate investor Dr. John Lewis Bryan, who died in 1867 after losing at least three sons in the Civil War. The sisters were generous philanthropists and noted patrons of the arts. They attended St. Paul Methodist Church, as did their architect, Carlos Schoeppl. The obituary for Caro in the *Houston Post* called her "a popular leader in many phases of the city's life and beloved by hundreds . . . a patroness of music and art . . . well known for many charitable donations." Johnelle's obituary two years later offered, "She was a contributor to the Houston Conservatory of Music." (Courtesy of Woodallen Photography–Houston.)

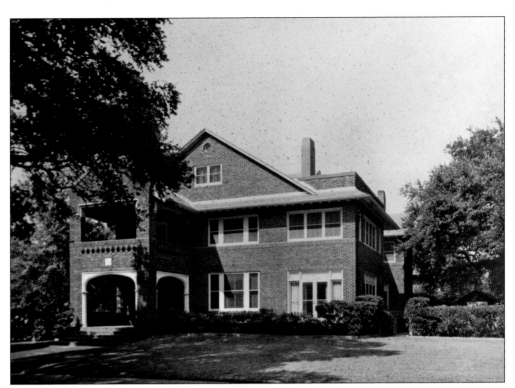

No. 24 Courtlandt was completed in 1921 by Alfred C. Finn for Sarah Brashear Jones, 1857–1925. Sarah purchased the lot from Capt. James Baker, who presented the adjoining lot as a gift to his daughter, Alice Baker Jones, and her husband, Sarah's son Murray Jones. Sarah's previous home on Main Street at Dallas, which had covered nearly three-quarters of a block, was pulled down and replaced by commercial development. Very fine architectural elements of the older house were incorporated into the home on Courtlandt Place, including the staircase, front and interior doors, paneling, brass hardware, and molding. A cabinetmaker worked for three months to reassemble the staircase. John Staub made interior alterations in the 1930s. Although Sarah occupied the home for only four years, her descendants lived there until 1989. (Both courtesy of Sara Stadeager-Andersen.)

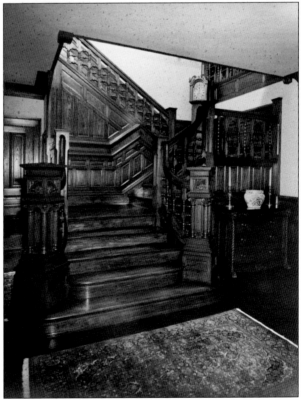

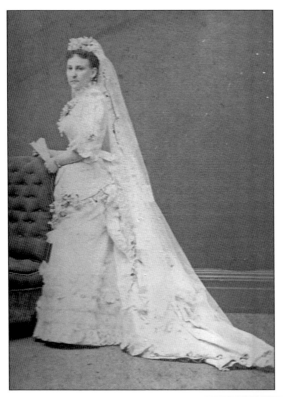

Sarah Brashear (left) married Col. James Warren Jones, CSA, at Christ Church Cathedral in 1875. Her father, Isaac Brashear, was a wealthy, influential landowner whose holdings included tracts of downtown property and a farm, which was later developed as the Houston Heights. Jones was a lawyer, served in the Texas Senate for six years, and was a member of the delegation to Congress that secured appropriations for the Houston Ship Channel. Sarah moved to Courtlandt Place after her husband's death. Her daughter Irma Jones Hunt, son-in-law William C. Hunt, and young granddaughter Effie Hunt moved with her. In the 1930s, granddaughter Effie Hunt Heald (below) held her wedding reception at 24 Courtlandt Place. Irma, Effie, and later Effie's daughter Sara had fabric and lace from Sarah's wedding dress sewn into their wedding gowns. (Both courtesy of Sara H. Stadeager-Andersen.)

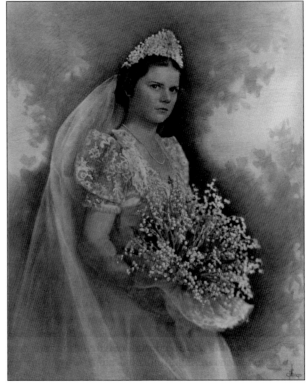

Irma Jones Hunt (1889–1973) inherited 24 Courtlandt Place upon her mother's death. She married William Cutter Hunt, "Willy," (1882–1955) in 1913. Willy grew up in New Orleans, attended Tulane University, and went into the shipping business in Galveston and then Houston. The Hunts were prominent members of society and belonged to both the Houston and River Oaks Country Clubs. Willy Hunt's passion was golf, which he first played at age 15. Granddaughter Sara Stadeager-Andersen relates that he was one of the first three men in Houston to own a set of clubs. A Texas State Amateur golf champion, Willy helped design the ROCC golf course; the club's Hunt Room is associated with him. Stadeager-Andersen states that when in Houston, Billy spent almost all of his time at the club and was rarely at home. (Both courtesy of Sara H. Stadeager-Andersen.)

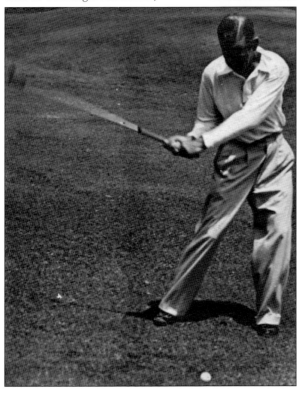

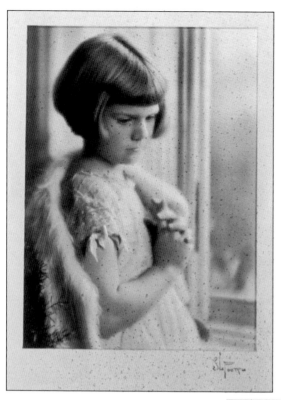

Effie Hunt Heald (1915–2004) was born into wealth and privilege. Her mother, Irma, attended Professor Welch's Academy, Miss Hargis' School, and then Miss Finch's School in New York City. Irma made her debut in Assembly, Houston's oldest social organization, took the Grand Tour, and lived in Paris for several years prior to marriage. The Hunts employed a staff of seven, entertained frequently, and dressed formally for dinner every evening. A less formal buffet supper was laid on Sundays, and guests were expected to drop by. Breakfast was taken on trays in bed. Irma spent her days going to luncheons, teas, parties, and playing tennis. The family traveled extensively in Europe, where Willy played golf, and spent summers at the Lake Placid Club in New York. Granddaughter Sarah Stadeager-Andersen states, "My grandparents lived the high life." (Both courtesy of Sara H. Stadeager-Andersen.)

Friends from New York and Europe and shipping and golf connections from across the world came to 24 Courtlandt Place. Irma ordered an extension crafted for the dining room table, creating a "T" shape for her large dinner parties. Houseguests were always in residence, often for extended stays. Irma's cousin Anne Morrow Lindbergh and her husband, Charles Lindbergh, visited and hosted the Hunts at their home in New Jersey. Capt. Günther Lütjens of the German navy visited in 1935 when his light cruiser, *Karlsruhe*, docked in Galveston. He presented a photograph of *Karlsruhe* to the Hunts. Promoted to fleet chief admiral in World War II, Lütjens was in command of the battleship *Bismarck* when she sunk HMS *Hood* in 1941. He died when *Bismarck* was sunk by a British fleet two days later. (Both courtesy of Sara H. Stadeager-Andersen.)

Effie Hunt graduated from the Kinkaid School and then completed Miss Spence's School in New York City in 1934. Irma lived in New York City with her much of the time. Effie's cousin and next-door neighbor, Alice-Baker Jones, attended the same schools, and the girls made their Houston debuts in Allegro, successor to Assembly. Effie married John Heald, an employee of Humble Oil, but the marriage ended in divorce when their daughter, Sara, was five. In a familiar pattern, Effie and her daughter lived in No. 24 with Irma, and Effie inherited the house when Irma died. The lavish lifestyle once enjoyed by the family became a memory; Effie, the sole remaining member of an original Courtlandt Place family still in residence, sold the house in 1989. (Both courtesy of Sara H. Stadeager-Andersen.)

EPILOGUE

This project grew from a home tour celebrating the Courtlandt Place centennial in 2006. An impressive amount of neighborhood history had been gathered beforehand, but the tour imbued many descendants of founding residents with a strong sense of nostalgia, and the foundations of a book were laid. The authors scrambled to keep pace as families came forward eagerly with collections of pictures and astounding stories to tell. Their response was remarkable—and overwhelming. The full content of information tendered by descendants, obviously hungry to share memories and lore of this very special place, would fill a volume twice this size. The trust placed in the authors to accurately represent these extraordinary people, who laid the foundations for modern Houston but can no longer speak for themselves, was gratifying and very humbling. The authors hope that Houstonians will recognize the importance of all of their historic neighborhoods, and they thank their many benefactors in this project, living and dead.

—Sallie Gordon and Penny Jones

Pictured are the residents of Courtlandt Place in 2009. (Photograph by Benjamin Hill.)

www.arcadiapublishing.com

Discover books about the town where you grew up, the cities where your friends and families live, the town where your parents met, or even that retirement spot you've been dreaming about. Our Web site provides history lovers with exclusive deals, advanced notification about new titles, e-mail alerts of author events, and much more.

MADE IN THE USA

Arcadia Publishing, the leading local history publisher in the United States, is committed to making history accessible and meaningful through publishing books that celebrate and preserve the heritage of America's people and places. Consistent with our mission to preserve history on a local level, this book was printed in South Carolina on American-made paper and manufactured entirely in the United States.

This book carries the accredited Forest Stewardship Council (FSC) label and is printed on 100 percent FSC-certified paper. Products carrying the FSC label are independently certified to assure consumers that they come from forests that are managed to meet the social, economic, and ecological needs of present and future generations.

FSC
Mixed Sources
Product group from well-managed forests and other controlled sources

Cert no. SW-COC-001530
www.fsc.org
© 1996 Forest Stewardship Council

Find Your Place in History.